POMPEII

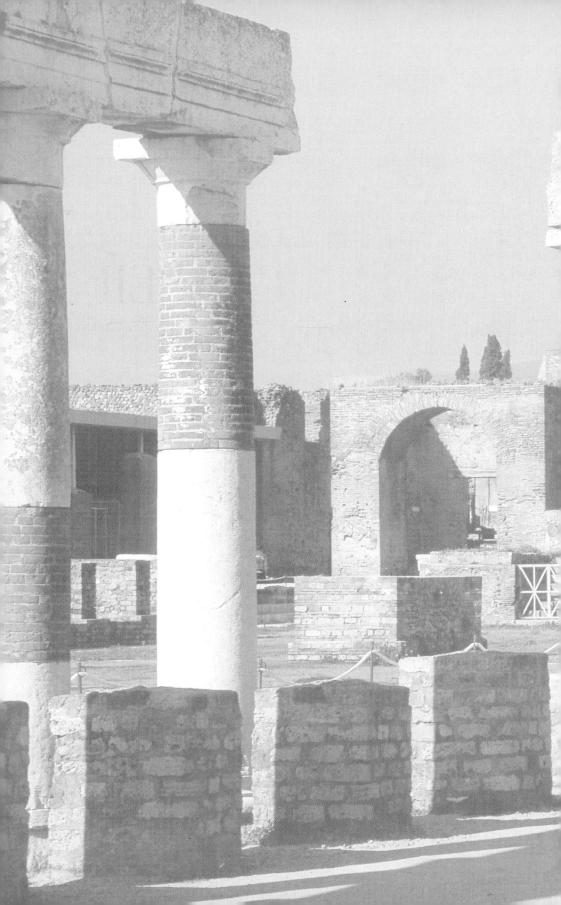

texts by
Pier Giovanni Guzzo
Antonio d'Ambrosio

photographs by
Alfredo and Pio Foglia

POMPEII

«L'Erma» di Bretschneider Electa Napoli

This volume was prepared by

editing
Silvia Cassani

graphic design and lay-out
Enrica D'Aguanno
Ivana Gaeta

Translation
Mark Weir

House plans
Ennio Gallo, Carmela Mazza

Front cover:
*House of the Vettii, detail of
decoration from the dining room.*

ISBN 88-8265-026-X
reprint may 2000

Contents

Introduction

The name of Pompeii means something to every educated European citizen. Since the middle of the 18th century, the discoveries in Herculaneum, Pompeii and Stabiae have aroused interest or curiosity in scholars and non-experts alike. The initial finds came quite by chance, during the sinking of a well, and the objects of ancient sculpture and decoration that came to light were eagerly compared with contemporary knowledge of classical antiquity. This derived almost exclusively from finds in Rome, where the Pope and his entourage of cardinals, drawn from the most influential aristocracy, held sway. The collections of statues, mosaics and furnishings, to say nothing of the extant monuments, from the Colosseum and Pantheon to triumphal arches and sculpted columns, were used to reinforce the legitimacy of the papal domination.

The new King of Naples, subsequently to become Charles III of Spain, astutely chose to exploit his own archaeological discoveries as an instrument of political influence. The conduct of the excavations was kept under the strict control of the Court. Would-be visitors to the sites and the collections which steadily built up in the Royal Palace in Portici had to obtain royal permission. The King was kept informed daily of the new discoveries made in the darkness of the tunnels carved out by the excavators. He appointed the scholars who made up the Accademia Ercolanese, created specifically to supervise the publication of the findings. What is more, it was the King who assigned the precious folio volumes containing engravings and descriptions of the frescoes, mosaics, statues and utensils to the fortunate recipients. In spite of this rigidly centralised control, weakened somewhat by the internal rivalries that were rife in the Accademia, interest and curiosity in the excavations spread rapidly all over Europe. Among the people responsible for divulging information about their progress was the founding father of modern archaeology, Johann Joachim Winckelmann. Born in Saxony but a long-standing resident of Rome, where he was librarian and antiquarian to Cardinal Albani, he was the leading expert on Rome's collections and monuments, and it was only natural that he should wish to compare them with what was emerging in Herculaneum and Pompeii. The restrictions and obstacles that were put in his way left him frustrated, and he soon perceived - and communicated to like-minded colleagues throughout Europe - the ingenuities and errors that characterised the conduct of the excavations. Yet at the same time he made no secret of the extraordinary interest in getting to know complete cities dating from ancient times. Such knowledge was not possible in Rome, which had continued to exist on its original site, so that old parts were invariably pulled down or built over and only the most prestigious monuments survived. When set against these masterpieces, the day-to-day objects that came to light in Herculaneum and Pompeii were bound to compare poorly from the artistic point of view. Yet there was the unprecedented quantity of wall paintings, of which hitherto not a single example had been discovered in Rome, and it was these, together with the theatre in Herculaneum that was emerging remarkably intact, which caught the imagination of Winckelmann.

It was early days yet for a true appreciation and scientific appraisal of antiquity, as can be seen in the reactions of Johann Wolfgang Goethe during his eagerly awaited journey to Italy. When he visited the houses that had been unearthed in Pompeii, he was greatly disappointed, referring to them as "doll's houses". The ideal concept of the classical, which predominated in the artistic taste of that period, clashed with the substance that was

coming to light. Goethe was in fact much more impressed by the majesty of the temples in Paestum, standing proudly amidst the silent marshes, imbued with a kind of moral consequence.

From those pioneering days we have come to a truly unique situation in which tourists and visitors can see a complete city of ancient times, transfixed during the eruption that buried it in a single night on August 24th 79 AD. Yet there are some things which make it hard to understand what one is seeing, not least the absence of all the decorative elements and free-standing objects. Furniture and decor, utensils, sculptures, ornaments, frescoes and mosaics have all been removed to the National Archaeological Museum in Naples, where they constitute our most comprehensive record of life and culture in Campania late in the first century AD. What the visitor sees are the walls, houses, temples, streets, fountains and theatres which still stand as they were built, the surviving skeleton of the city as it appeared in what suddenly became the last phase of its evolution.

In 79 AD life in Pompeii already had a history stretching back about a thousand years. The Sarno river continues to flow into the Mare Tirreno as it did in earliest times, rising at two springs below Monte Torrenone and flowing through the wide, fertile flood plain of Nola. It reaches the sea in a low-lying, marshy part of the coast between the Sorrento peninsula and the southernmost slopes of Vesuvius, an area dotted with mounds marking an ancient volcanic crater. On one of these, in the locality of Sant'Abbondio, a settlement has been found dating from the Middle Bronze Age, about 1500 BC. To date we know the necropolis, comprising trench tombs sunk in the reddish soil. The corpses were placed in a crouching position with token grave goods in the upper part of the trench. Each grave was covered with large stones, and in some cases there was a small additional chamber.

The city of Pompeii was to develop on the largest mound in the area. Here too there was a settlement in proto-historic times, from which a few fragments of pottery have come to light, but no clear evidence of dwellings. The Bronze Age culture was also interrupted by a catastrophic eruption of Vesuvius. Recent excavations at Palma Campania, between Pompeii and Nola, have revealed a village buried under the ash and pumicite thrown out by the volcano.

The commanding position of this mound favoured its occupation during the Iron Age after 1000 BC. Extending for more than 70 hectares, it dominated the mouth of the Sarno river and hence made it possible to control both movement along the river valley and also the landing-point for craft in the Bay of Naples. The Sarno flood plain was criss-crossed with settlements dating from between the ninth and seventh centuries BC. San Marzano, San Valentino Torio and Striano account for most of our knowledge, revealed above all in their necropolises. The material remains reflect the period known as the "trench tomb" culture. The dead were buried in trenches hollowed out in the ground, where they were laid accompanied by grave goods comprising personal belongings and ritual vessels. The varying composition of the goods makes it possible to distinguish the sex and age group of the corpse, and also, in the more recent burials, the social status. We have a clearer idea of the overall chronology thanks to the presence, alongside local artefacts, of pottery vessels manufactured in the Greek colony of Pithekoussai on the island of Ischia. This colony was founded by merchant adventurers from the island of Euboea towards

Vesuvius and the Forum
of Pompeii

Pompeii seen from the Tower
of Mercury

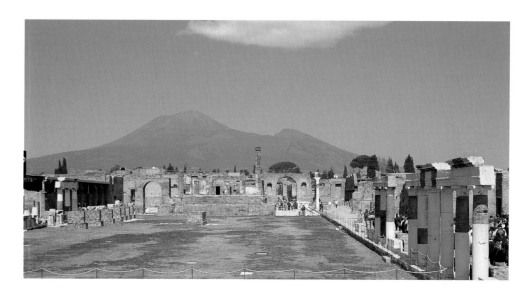

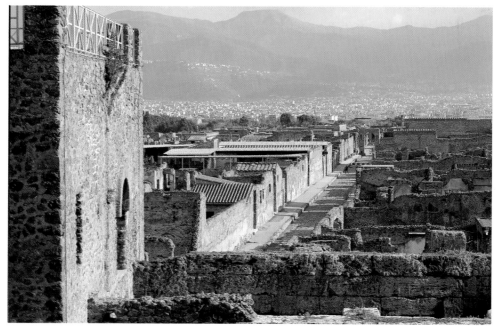

Forum Baths, tepidarium,
detail of the stucco decoration
on the ceiling with Ganymede
carried off by the eagle.

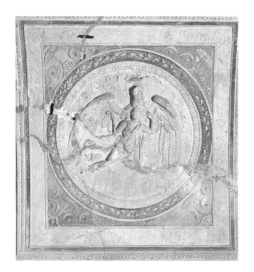

the middle of the eighth century BC, making Ischia the longest-established Greek settlement in Italy. The trading interests of Pithekoussai, inhabited not only by Greeks but also by Phoenicians and other voyagers from Asia Minor, spread as far afield as Etruria, and naturally trade was intense with the coastline of Campania across the Bay. As we have said, the mouth of the Sarno offered good anchorage and the river itself gave access to the hinterland. The current state of our knowledge does not enable us to be certain that the settlement at Pompeii was actively involved in this trading, but there may be analogies with the evidence that has emerged at Pontecagnano (in the province of Salerno). The development of this settlement, situated at the mouth of the Tusciano river, clearly owed something to its commercial dealings with the Greeks of Pithekoussai, while no such evidence has come to light for the indigenous community on the headland of Cumae, for example. Thus in the absence of material finds in Pompeii, and considering the ambiguity of the local situations, it

seems prudent to leave the specific question of contact between Pompeii and Pithekoussai open, while confirming the broad reconstruction of the development of the Sarno plain during this period. The original settlements inland were gradually superseded by the new centres of Nocera and Nola, while we find evidence of settlers in the course of the seventh century BC in the area of Boscoreale, and a new coastal settlement took root in the locality of Madonna delle Grazie in present-day Castellammare di Stabia.

The overall picture of the spheres of influence in Campania in about 600 BC is dominated by the forceful expansion of the southern Etruscans. For the previous two centuries they had been securely settled at Capua, on the Volturno river, whose mouth offered mooring for ships coming from Cerveteri and Vulci. The growth of the main cities in Etruria itself, Vulci in particular, gave renewed vigour to these exchanges, which came to compete, in a certain sense, with the contemporary extension of Greek interests. The descendants of the colonisers of Pithekoussai had by now been settled for a century on the mainland at Cumae, and from here they had spread to Pozzuoli and at least as far as Parthenope (Naples). Scholars do not agree whether the Etruscan expansion in Campania came about principally over land or by sea. What we do know for certain is that Etruscan artefacts are always to be found both in coastal sites and inland. Thus in Castellammare di Stabia, in addition to *bucchero* (Etruscan black pottery), finds have included Etruscan figured vases made in Vulci. Pompeii has also afforded many fragments of *bucchero* intermingled with those of Greek black figured vases, illustrating the complexity and inter-relatedness of commercial exchanges in Campania in the archaic period. We can recall that the local languages of the

House of the Vettii, miniature showing naval battle.

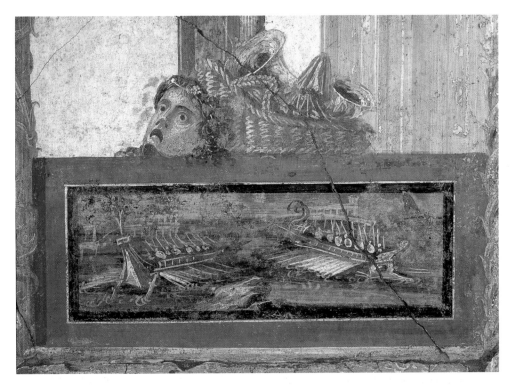

indigenous Italic peoples were set down in alphabets which derived from the Etruscan rather than Greek model. The steady accumulation of heterogeneous material and cultural elements in this part of the region gave rise, in the mid-6th century, to a radical restructuring of the settlement at Pompeii.

On the summit of the mound a sanctuary was erected, apparently in honour of Apollo, matched by a second shrine situated on the settlement's southeastern slopes. The latter was completely surrounded by a defensive wall built of rectangular blocks of *lava tenera* (a volcanic rock). In the northwestern section (later Regio VI) we know of at least one construction situated inside a

beech grove which was also probably a shrine, venerated by travellers belonging to the Etruscan culture. Taken together, these finds enable us to affirm that the restructuring of the ancient settlement overlooking the mouth of the Sarno was designed to ensure both greater security for its inhabitants and facilities for receiving and doing business with visiting traders. It seems likely that the temple in the southeast (later known as the "Triangular Forum") was dedicated to Hercules, the semi-divine hero who presided over shrines erected in areas of exchanges and boundaries between residents and outsiders, as at the famous Pillars of Hercules and the sacred precinct near the ancient port on the Tiber in

Rome. Furthermore, the location of this temple on the slopes running down to the river emphasises its marginal nature, in stark contrast to the centrality of the Temple of Apollo, and this may represent another clue as to its function: here it was possible to have dealings with outsiders and carry on trade without admitting them into the settlement itself.

The material that has come to light in Pompeii dating from the 6th century BC belongs to both the Greek and Etruscan cultures, but scholars have engaged in heated debate over who actually controlled the settlement. We would suggest looking at the question differently, for the valley of the Sarno and its stretch of coastline appear to have been under the control of the indigenous Ausonians. Helped by continuous and fruitful contacts with both Greeks and Etruscans, the local people took over their neighbours' most significant achievements, and built defensive walls or erected sanctuaries in which to worship the local gods, achieving a syncretism with the practices of their visitors. Thus we can suppose that Pompeii in archaic times (and indeed in subsequent epochs) was not under the political control of either Greeks or Etruscans; instead, thanks to its advantageous setting and the opportunities offered by its hinterland, it promoted the meeting and mingling of different peoples in the interest of trade and exchanges. The Aurunci took advantage of this situation and showed themselves able to deal with visitors not simply on an equal footing but so as to increase their own prestige.

Such an interpretation, it must be said, seems to clash with a passage from Strabo (5, 4, 8): "The Oscans held Herculaneum and the neighbouring Pompeii, in the vicinity of the Sarno river; after them it was held by the Etruscans and the Pelasgians, and later still by the Samnites, who finally were driven out (by the Romans)."

As usual in the writings of this geographer of the first century BC, the description of events is very cursory; what is more, he mentions both Etruscans and Pelasgians. This mythical race is generally taken to be a generic reference to indigenous peoples whose names had passed into oblivion but who were believed to have had dealings with the Greeks. The archaeological evidence suggests that the Etruscan presence was more deeply rooted further inland, between Capua and Pontecagnano, than on the coast. Furthermore, none of the excavations carried out in Pompeii so far has brought to light structural elements referring to the Etruscan culture rather than to the mixed culture that was widespread in the area. And finally it must be remembered that Strabo was writing with an eye to his readership: he tends to refer in a general way to peoples whose names were familiar and focus on cultural rather than ethnic characteristics. Again as archaeology has shown, there was no shortage of Etruscan materials in Pompeii.

The settlement inside the walls made of *lava tenera* would seem to be predominantly Ausonian, with shrines and possibly clusters of dwellings for non-indigenous people. In spite of our almost complete ignorance of constructions dating from the archaic period, we do nonetheless have some elements to confirm the version of history passed on by the ancients. In archaic times the dwellings in indigenous settlements must have been impermanent, made of wood or sometimes unfired bricks. These phases of a settlement would later have been destroyed as foundations were dug and constructions in masonry put up, and this would explain why we have no records of these first phases of the settlement.

Finally, it seems that the name "Pompeii" goes back to the archaic period. The toponym has an Italic root,

*House of the Golden Cupids,
marble relief from the garden
with masks of a Maenad
and Pan.*

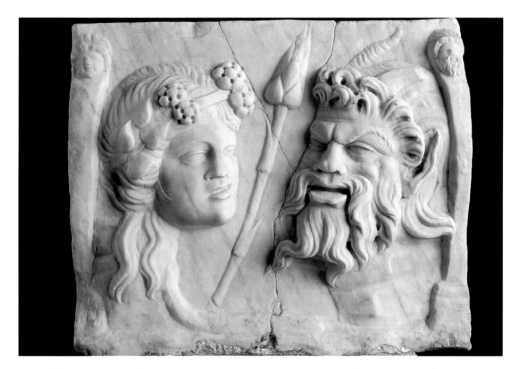

assimilable to the number five. This might mean that five ethnic groups joined together as a federation to control the mouth of the Sarno. However, given that five is the number of fingers on one hand, this may have been a generic reference, indicating that Pompeii gathered together all the groups from the neighbouring region (whatever the precise extent of that region). It also seems that the population of Pompeii increased as the neighbouring settlement of Stabiae declined, suggesting that there was only room for one centre to control and exploit the commercial opportunities offered by the lower valley of the Sarno. Whether this supremacy was established peacefully or with recourse to violence it is no longer – or perhaps not yet – possible for us to say.

We can hope that further evidence about this period may emerge at Herculaneum, which Strabo brackets with Pompeii. The toponym of this coastal site is clearly Greek, deriving as it does from the name of Hercules. However, it is not clear whether it comes from a homologous Italic toponym which also referred to the hero, who was widely revered among non-Greeks, or is merely linked by assonance. The existence of toponyms comprising the name of the hero in the area is confirmed by the ancient name, Petra Herculis, for the island now known as Rovigliano off Castellammare di Stabia.

The struggle between the Etruscans and Greeks for total hegemony in Campania culminated in the decisive naval battle of 474 BC in which the Etruscan fleet was

House of the Vettii, painting
showing the myth of Ission.

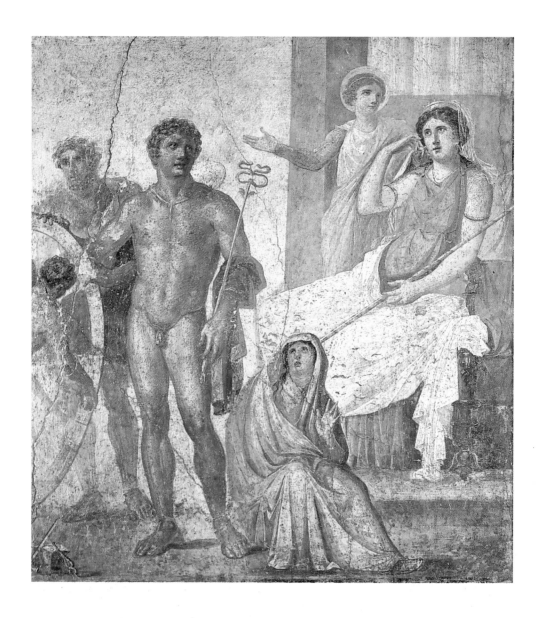

routed by forces from Syracuse. This victory permitted the Greek cities of Cumae and Neapolis to extend their commerce and spheres of influence without competition from the Etruscans. This is the general context, albeit lacking in detail or a clear sequence for the events, in which the existing defensive wall around Pompeii was rebuilt. The structure in *lava tenera* was sheathed in rectangular blocks of solid limestone from the Sarno valley and reinforced with the addition of square towers. We do not know who was responsible for supplying either the necessary engineering skills or the political and financial backing: the features of the wall's design and construction do not point unequivocally to any one of the three protagonists of the moment, Greeks, Etruscans or the Italic people who were in the process of being assimilated by the Samnites. It is quite possible that the indigenous residents had formed an alliance with either the Greeks or the Etruscans in order to ensure the best possible technical know-how for this important enterprise.

Both the reconstruction of the walls, maintaining the circuit of the previous structure in *lava tenera*, and in particular the positioning of the city gates are indicative of the collocation of Pompeii in the wider communications network. The city comes to be seen as both a component and an indicator of that settlement of the territory which the progressive supremacy of the Samnites, complete by the end of the 5th century BC, sanctioned in the form that lasted until the advent of the Romans. It may be possible to infer a partial change in the commercial dealings carried on by the city in the light of a new development. During the second half of the 6th century BC a shrine had been erected, and possibly dedicated from the outset to the sea god Poseidon, in the locality of Bottaro on the most seaward of the sand spits

in the mouth of the Sarno river. We currently have material evidence from this site dating from archaic times and from the 4th century BC onwards, but nothing from the 5th century. This may indicate a lessening (although not a complete interruption) of maritime activity in this period, to add to the fact that there are no known 5th century remains from Stabiae. Perhaps at this time the trade routes went primarily overland, in the context of a regional development determined both by the cessation of seaborne relations with Etruria and Syracuse's domination of the sea and by the growing prosperity of the Greek agricultural centres of Cumae and Neapolis and the Samnite communities in the plains of the hinterland. Among the latter the most interesting for our purposes is Nola, where a number of high quality red figured Attic vases originated.

This conclusion also reflects the progressive stabilisation of the layout of Pompeii inside the walls, which was taking on a recognisable urban configuration. The mound's natural morphology afforded two main access points on the north side: one that was to become the Vesuvius Gate (Porta Vesuvio) and the other the Herculaneum Gate (Porta Ercolano). The former served the route that went round the side of the volcano and headed inland while the latter gave onto the coast road and led towards Herculaneum and Naples. On the southern side of the city, the plateau of the mound is pierced by a gorge which provided a natural course for the road from the Vesuvius Gate to Stabia. The road to Nocera started out from the Nuceria Gate (Porta Nocera), and seems to have developed as a deviation from the Stabia road. The subsequent urbanisation of the eastern sector of Pompeii must have obliterated all trace of this route within the circuit of the walls.

The geomorphological features of the site have been

*Villa of the Mysteries, detail from
the life-size painting*

rationalised into a number of sectors that divide up the intramural urban layout. The southwestern sector corresponds to what has traditionally been referred to as the *Altstadt* or ancient city; this does indeed include the centre of the city with the forum and temple of Apollo, but the street layout here is irregular. The northwestern sector (mainly Regio VI) conserves the urban stretch of the coastal road we have postulated, leading towards the central square of the Forum; one clear indication of its existence is the way in which via Consularis disrupts the urban grid pattern in Insula 4 of Regio VI. The two eastern sectors are delimited on the western side by the Stabia road running from the Vesuvius Gate to the Stabian Gate (Porta di Stabia). Their topography and dimensions suggest that they originated in the subsequent development of the city during the 5th and 4th centuries BC.

Even though we still lack the comprehensive and incontrovertible archaeological evidence about the residential quarters of this period that can only come from stratigraphical excavating, we can assume that by 300 BC the city of Pompeii had taken on the configuration that was to persist, with the progressive extension of the built-up areas, right through to 79 AD. The intervening period saw the succession of events known as the Samnite Wars, in which Rome and the Samnite peoples, above all those living in what is now Campania, fought to assert their hegemony over this particularly rich and desirable region. The struggle went through alternating phases, with the Roman army being defeated at the Forche Caudine, but in the end triumphing over the Samnite forces. This is the context for the following passage from Livy (9,38,2-3), writing about events in 310 BC:

"A Roman fleet descended on Campania under Publius Cornelius, whom the Senate had put in command of the coastal defences; dropping anchor off Pompeii, the allied forces (comprising Romans and allies from other cities in Latium) divided up to sack the countryside around Nuceria. They had soon dealt with the coastal region, so as to be able to regain their ships, but, as happens all too often, they were seized by greed for still more booty and pressed forward, provoking the enemy forces. Yet these did nothing to hamper them, even though with the Romans widely scattered, they could have wiped them out. However, as the Romans were returning to their ships without any care for security, the peasants fell on them not far from the ships, seizing all the booty and killing a number of them. Those who escaped the massacre took refuge in the ships, shaking with fear."

We can see that Pompeii maintained its function as a vantage point controlling the landing-point at the mouth of the Sarno and traffic up the river. The good condition of its fortifications dissuaded the Romans from attacking the city, and they turned their attention to the countryside "around Nuceria", which appears to have been a more important city than Pompeii. We also see that the countryside was populated by Samnites engaged in farming activities, and it was their produce that enticed the Romans and their naval allies. In the light of this agricultural production in the neighbourhood of Pompeii, the city streets leading out into the countryside must have been increasingly important. This explains why the new urban layout conserves these arteries but takes on the grid-like regularity that distinguishes a planned development and isolates, so to speak, the haphazard street layout of the southeastern section (*Altstadt*). The importance of the overland communication routes is further borne out by the discovery of burial grounds dating from the 4th and 3rd centuries

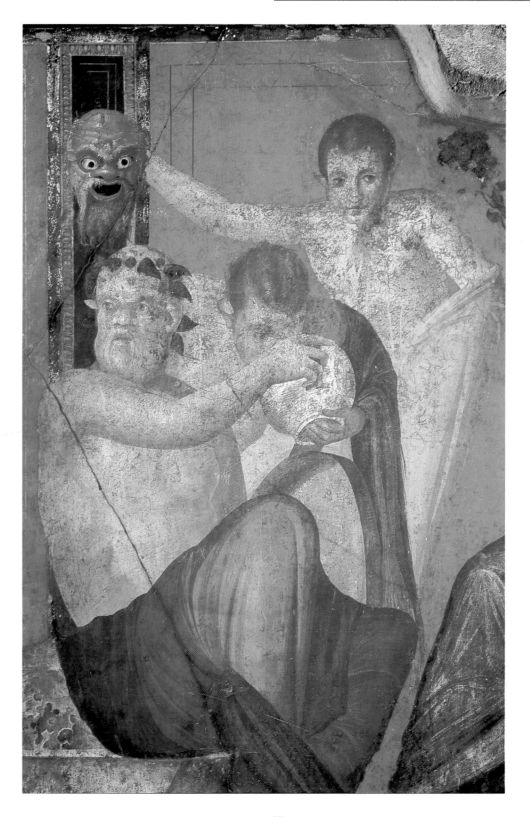

BC in the area immediately outside the Stabian Gate, to the south, and the Herculaneum Gate, in the northwest. These burial sites correspond to the ones known to us in other contemporary Samnite settlements in which the dead are buried in either trenches or chests made of stone slabs. The grave goods comprise pottery vases in black varnish and red figures of local manufacture, and in some cases bronze objects as well. The presence of the necropolises is a mark of importance and suggests that these routes were frequently used. It is even more significant that the agricultural plots to the north of Pompeii, at least as far as the present-day Boscoreale, seem to have been laid out on a regular pattern, which in all probability corresponded to the orientation of the main arteries. Going back to the suburban necropolises for a moment, we can observe that outside the Vesuvius Gate, which forms the northern access point corresponding to the Stabian Gate in the south on our proposed artery, research has concentrated so far on the recovery of the Roman necropolis: only evidence of finds relating to Samnite burials will provide the definitive archaeological proof for the urban street layout we are putting forward.

The passage from Livy provides one more piece of information. Pompeii is mentioned as little more than a place name. Of course the object of the expedition was Nuceria, not least in order to punish an ally that had recently reneged on Rome and gone back to the Samnites. However, although the raiders pushed imprudently far inland, they did not attack the renegade, for the city was surrounded by defensive walls, as we know from archaeological evidence and can deduce from Livy. In this it resembled Pompeii, whose defences in these years consisted not just in the walls of Sarno limestone, but in a new military-style fortification probably only recently completed. This explains why the Romans avoided the stronghold and preferred to overrun the defenceless farms and estates. It is quite likely that as the raiders came ashore the peasants took refuge in the city of Pompeii, from where they subsequently rushed out to fall on the returning troops made happy-go-lucky by their successes and burdened with spoils.

The "new" walls were also faced in rectangular blocks of Sarno limestone and built up with earthworks to encase what was still standing of the previous walls. Subsequently reinforced with square towers, these walls were further strengthened during the 3rd century BC, possibly during the period Hannibal's army spent in Campania. There are numerous quarry marks in the form of Oscan letters carved on the blocks used in the construction, indicating either the quarry of provenance or the team of masons involved in erecting the various sections of the fortification. Now that the internal structure of the city was fixed, its integration with the surrounding territory was reinforced by the orientation of the two roads leading to Nola and by via dell'Abbondanza. These routes led eastwards towards the summit of Monte Torrenone, from whose flanks the Sarno river sprang and the site of a federal Samnite sanctuary. The lack of plentiful and specific archaeological data which could determine the development of the urban layout oblige us to assume that it was defined during the 4th century BC and continued to develop over the next two centuries. Given such an imprecise chronology it seems unwise to hazard a comparison with the formation of the Latin colony at Paestum (273 BC), in spite of the inviting analogy of the tripartite division of the main north-south orientation. Rather than taking this to indicate a mutual influence, the instigator of which has scholars at odds, it seems more sensible to

*Villa of the Mysteries, detail
from the life-size painting*

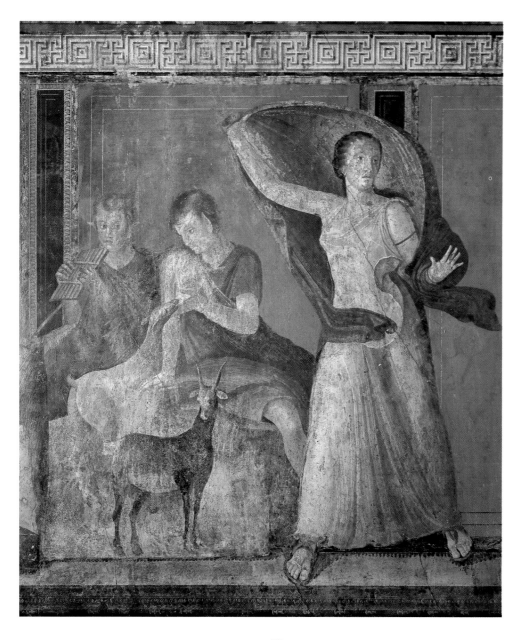

reserve judgement and recognise a patrimony of urban know-how common to Romans and Samnites alike, especially in view of the fact that the layout of the colony at Paestum was conditioned in part by the numerous features surviving from more than a century of Samnite domination of the former Greek settlement.

In Pompeii the north-south orientation corresponds to an earlier route whose tripartite division only concerned the two eastern sectors. The development of these sectors was influenced by the internal dynamics of the Samnite community in the surrounding territory, albeit within the general political context of the conflict with the Roman Republic. There is no doubt that the culture for which we have clear evidence in Pompeii up to the time of the Social War in 89 BC is thoroughly Samnite. This is true for the language and the institutions, and includes the unmistakable presence of individuals or groups who continued to use the Etruscan language, as can be seen from various graffiti. Thus work still has to be done on the cultural matrix in which the division of spaces that determined the eastern sector of the city as we know it today evolved or was adapted from other models.

The urban hallmarks of the Etruscan and Roman city-builders are common knowledge, but the same cannot be said for their Samnite counterparts, while the regularity of the agricultural plots between Pompeii and Boscoreale, mentioned above, should suffice to stimulate further investigation on this score. This seems particularly important for the Italic communities along the Tyrrhenian coast, including Pompeii. From the late 5th century onwards they took over urban centres which were already constituted, whether in Cumae, Neapolis or Poseidonia. Then, during the latter part of the 4th century, Italic settlers in Laos (now Marcellina in the province of Cosenza) laid out a fortified Lucanian town-ship on a grid pattern, possibly the first urban definition of an Italic site *ex novo*.

However, this sort of reasoning cannot take us very far. In Pompeii, as we have said, we lack plentiful, stratigraphically verified archaeological finds from the main period of Samnite presence to set alongside the contemporary evidence from the necropolises. The most convincing material evidence was found under a house dating from the 2nd century BC in Regio VII. During excavations part of a building came to light which was plausibly identified as a public banqueting hall, the extant rooms containing ledges on which couches for the guests would have been set. Such buildings are known to us in at least two other Italic cities: in the Lucanian site of Buccino (in the province of Salerno) and in Capua, the principal Samnite centre in Campania. These buildings were the venue for banquets held by associations whose Oscan name was Vereiia, which constituted the backbone of the Italic social organisation and were generally organised by age group. This discovery clarifies the ethnicity and culture of Pompeii and ties in with the numerous graffiti and inscriptions, some from monuments, that have come down to us in Oscan. The texts of these graffiti are varied and include both public and private sentiments. Together with the use of the Oscan foot measuring 28.5 cm, they help to flesh out the bare bones of a generic historical periodisation.

The second Punic War came to an end at Zama in 202 BC, and the favourable outcome opened the way for the Roman Republic, without fear of competitors, to extend its influence throughout Southern Italy. Round the coast it implanted a ring of colonies, stretching from Buxentum to Siponto, which strengthened the control previously maintained through its strongholds at

Venosa and Paestum. The eastward extension brought rich new markets within reach of both Roman and Italic traders, revolving around the free trade port set up on the island of Delos in the middle of the Aegean, strategically placed for voyages to the opulent cities of Asia Minor. These new opportunities probably spurred the inhabitants of Pompeii to exploit both their local products and the new demand, not least because they were situated conveniently close to the port of Puteoli (Pozzuoli), the final destination of all Italian trade across the Mediterranean.

The east was a tangible presence: oriental artefacts were in demand for house furnishings, eastern religions like the cult of Isis found new adepts, and wheat was sold in Greek units of measurement, probably due to the importance of Alexandria. However, in spite of these thriving exchanges Pompeii's fundamental loyalty to the hegemonous Republic was never in question. Thus we find the master of the House of the Faun inscribing the Latin greeting *Have* on the threshold of his sumptuous abode while adopting decorative schemes which were overtly Egypto-Hellenistic in taste and iconography. This is seen to spectacular effect in the floor mosaic adorning the second tablinum, a masterful reproduction of the famous painting by Philoxenos of Eretria showing Alexander the Great bearing down on the Persian ruler Darius at the climax of the battle of Isso. With its surviving first period frescoes, its façade built in limestone blocks and the symmetrical distribution of the rooms round the atrium, this house stands as an excellent example of the type of private dwelling already popular in the 3rd and 2nd centuries BC and which continued in use up to the city's destruction. It also illustrates how the original division into urban lots was modified with the passage of time and the changes in

family fortunes. As we know it today, the House of the Faun has clearly absorbed at least two other adjacent houses.

The buildings in use in 79 AD in the centre of Pompeii originate from structures dating, by and large, from the 3rd and 2nd centuries BC. It was in this period that more durable building materials were employed, obviating the need for continual refurbishment and gratifying modern archaeologists with material remains. As we have already said, previous constructions in the private sphere used more perishable materials and techniques, which have not come down to us in any adequate form. This however was not the case for religious edifices, and the Tuscan order column dating from the archaic period incorporated into a wall in the Hellenistic period must have been set up for devotional purposes in some such temple, although by the time it was reused its original significance had vanished from the collective memory.

It was not only structures that disappeared as new ones took their place: the same went for frescoes, and the majority of those known to us today belong to the latest of the four commonly identified "styles". There are relatively few examples of the second and third styles, for they were either destroyed or covered over during repeated redecorations and modernisations. In fact, every building in Pompeii represents an example of "work in progress", having been subjected to refurbishment and modernisation repeatedly in the space of the three centuries preceding 79 AD. It was not only a question of the changing needs of the house owners; frequent earthquakes made structural repairs a constant problem. We know from written records of an earthquake that occurred in 62 AD, and archaeologists have been able to trace the damage it produced in both public and private buildings from this last phase of life in Pompeii. This

*House of the Vettii, detail
of painting.*

event was the direct cause of the munificence of Numerius Popidius Celsinus in restoring the badly damaged temple of Isis, whereas it seems that the bas-relief showing buildings collapsing and severe damage must refer to a previous earthquake.

Although a Samnite city, Pompeii was a close ally of Rome, and remained faithful to the Republic during the Social War. However, shortly after this it defied the dictator Sulla, who laid siege to the city and conquered it. He then put his nephew Publius in charge of founding a colony named Cornelia Veneria Pompeianorum there in 80 BC, marking the event with the spectacular construction of the Temple of Venus. Situated on the south-eastern spur of the mound, its dazzling white marble became a landmark at the entrance of the city for all travellers approaching along the traditional road from the mouth of the Sarno. At a stroke Sulla had overturned the traditional iconography of Pompeii, which no longer looked inwards to the countryside but opened

out onto the sea. It is also true to say that this temple, which was probably commissioned by Sulla himself as a faithful devotee of the goddess of fortune, represents the earliest instance in Pompeii of the adoption of a Mediterranean style of architecture. This can be seen in the use of capitals of the "normal Corinthian" rather than the "Corinthian-Italic" order which had hitherto prevailed. But above all it is the general aspect which echoes Hellenistic architectonic models and testifies not simply to a new taste in building but to the inclusion of the city in a broader circuit of cultural relations than had been the case up until now. For all this, the economic basis of Pompeii continued to be farm produce. The agricultural holdings nearest the city were assigned to the two thousand legionaries from Sulla's army who constituted the colony. This accounts plausibly for the radical transformation of the original nucleus of the Villa of the Mysteries, and of the residences known as the "villa of Cicero" and the "villa of Diomedes". The

House of the Vettii, detail of painting.

frescoes in these buildings are in the 2nd style and can be dated to the years immediately after 80 BC. On the other hand, the considerable number of houses which still contain (or, in many cases, did contain until the earthquake of 62 AD) decorations in the 1st style are likely to have belonged to Samnite families who, once the difficult episode of the colonisation had passed, continued to live in the city and became progressively Romanised. The clearest example of this is to be seen in the House of the Faun.

The urban layout changed radically immediately after the institution of the colony, above all to make provision for the public buildings required by the new inhabitants. Thus the *odeion* or covered theatre was built for the performance of plays in Latin, whereas in the larger, open air theatre performances were probably in Oscan. Cicero, writing a generation later, records that in Pompeii you could still see plays in Oscan. Similarly, the construction from scratch of the Forum Baths suggests that this establishment was intended to complement the earlier Stabian Baths used by the Samnite inhabitants, although these too were partially refurbished during this period. With respect to religious edifices, the so-called Temple of Zeus Meilichios and the most recent additions to the altar in the Temple of Apollo can be dated from the first generation of the colony's existence. But the major building project was the restructuring of the original Temple of Jupiter situated on the short northern side of the Forum, according to a typical model of the *capitolium* symbolising the might of the Roman presence.

More generally, the fact that the city walls were no longer needed for defensive purposes meant that building work could extend beyond the city's perimeter and, with its splendid panorama on the seaward side, this provided a perfect setting for villas for the rich. By the middle of the first century AD this development had spread westwards as far as the Porta Marina (Sea Gate), in front of which the Suburban Baths were constructed complete with a sophisticated heating system for the covered swimming pool. The most significant construction of this phase was probably the Amphitheatre, built at the personal expense of two of Sulla's commanders, Gaius Quintius Valgus and Marcus Portius, during their five-year term as magistrates. It testifies to the traditional Samnite love of gladiatorial contests but in times of peace, in a city in which the descendants of long-established families and new residents could regard the city walls as a convenient infrastructure for their building projects rather than a vital military resource.

The inscriptions that have come down to us tell us more about the purposes of these public buildings than the

chronology of their construction. They embody the mutation in the political regime which accompanied the institution of the colony as well as the primacy of the Latin language, two developments which caused problems in what we would call the domain of law and order within the city, as the descendants of the original citizens and the politically and militarily favoured newcomers had to learn to live together. We can imagine that the harmonisation of what Cicero referred to as these two "types of Pompeiian citizen" was sealed ten years after the formal founding of the colony, in 70 BC, with the taking of a census to define the status of the citizens, their respective liability for taxation and the property they possessed. This was also the time at which work was begun on the amphitheatre, whose significance we have just mentioned. Its dimensions were truly massive, for it could hold 20,000 spectators, suggesting that the magistrates Valgus and Portius meant it as a venue for all the population from the countryside and surrounding towns as well as the citizens themselves. This was indeed the case for the next generations, for in 59 AD it was the scene of a terrible brawl between inhabitants of Pompeii and Nocera.

This is how Tacitus records the episode (Annals 14, 17): "There was a serious fight between the inhabitants of two Roman settlements, Nuceria and Pompeii. It arose out of a trifling incident at a gladiatoral show given by Livineius Regulus. During an exchange of taunts - characteristic of these disorderly country towns - abuse led to stone-throwing, and then swords were drawn. The people of Pompeii, where the show was held, came off best. Many wounded and mutilated Nucerians were taken to the capital. Many bereavements, too, were suffered by parents and children. The emperor instructed the senate to investigate the affair. The senate passed it to the consuls. When they reported back, the senate debarred Pompeii from holding any similar gathering for ten years. Illegal associations in the town were dissolved; and the sponsor of the show and his fellow-instigators of the disorders were exiled."

The century and a half that went by before the eruption of 79 AD saw the gradual assimilation of the prevailing Roman culture in Pompeii. Earthquakes and political milestones left their mark in the continuous refurbishments of the buildings and the succession of decorative "styles", the modernisation of the Forum, the erection of the Temple of Fortuna Redux during the reign of Augustus and the construction of the aqueduct. With social and economic progress new criteria for house building emerged in which sheer size and grandiose layout were superseded, reflecting a tendency to economise on space and expenditure in a period of political stability and wellbeing.

The Forum can be seen as emblematic of the Imperial period in Pompeii. The old market square of the Samnite city was restructured to embody the dominant culture. The temples of Apollo, to whom Augustus was particularly devoted, and Jupiter, the god of the capital city, were set up on the western and northern sides of the square, the latter being embellished with equestrian statues and triumphal arches to celebrate successive emperors. The eastern side was no less loyalist in its fabric, comprising the temples of Vespasian and the Public Lares and the "building of Eumachia", whose purpose is unclear but which was undoubtedly connected with the imperial family. This is borne out not only by the presence of a statue of the goddess Concordia with the features of Livia, wife of Augustus and mother of Tiberius, but also by the inscriptions celebrating Romulus and Aeneas, honoured respectively as the

*Villa of the Mysteries, detail
from the life-size painting*

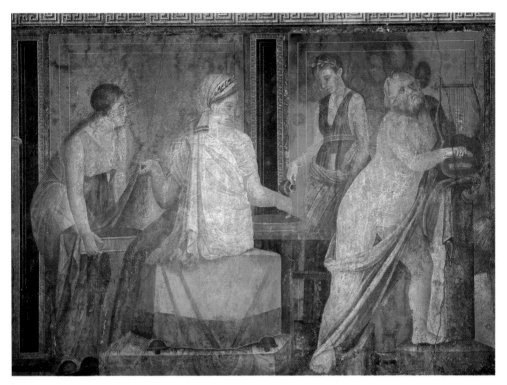

founder of Rome and of the Julius family to which Augustus belonged.

The public, ceremonial area of the Forum extended northwards to where the junction between via della Fortuna and via di Mercurio was marked with another triumphal arch, possibly dedicated to Caligula, and to the temple of Fortuna Redux, undertaken by Marcus Tullius at his expense and on land he owned. He belonged to a subsidiary branch of the Tullia family, that of the great Cicero who was assassinated during the second triumvirate without intervention on the part of Octavian, the future Augustus. Thus this peripheral temple to the goddess Fortune is another concrete example

of the contrasts within one leading family being finally reconciled under the wise primacy of Augustus.

The public aspect of the last two generations of life in Pompeii owed much to the completion of the aqueduct, an offshoot of the original Roman construction to convey water from the Sirino river in the province of Avellino to the base of the imperial fleet at Misenum. The main tank was situated near the Vesuvius Gate on the highest ground in the city. From here pipes led to subsidiary tanks, public fountains and both public and private installations. The thermal establishments were rejuvenated by this new abundance of water: the Stabian and Forum Baths had a facelift with new figurative deco-

rations in stucco while new establishments were built outside the Porta Marina, between via Stabiae and via di Nola and on the slopes facing the sea. Home owners too incorporated their own thermal baths which they sometimes opened to the public (as at the Villa of Julia Felix), or else they adorned their gardens with fountains and waterfalls (as in the House of Loreius Tiburtinus). All these innovations were sealed by the eruption of Vesuvius, which raged from the afternoon of August 24th through to the 26th. The phases of this conflagration were recorded, albeit a few years later, by Gaius Plinius Secundus, who in 79 AD was seventeen years old and staying with his uncle, an admiral in the imperial fleet and a keen naturalist. He was persuaded to narrate the events by Tacitus in two letters (nos 16 and 20 in Book VI of Pliny's collected letters), when the latter was acquiring material for the second part of his *Historiae*.

Those last days of August had been preceded by earth tremors, a common enough phenomenon in Campania that aroused no particular apprehension. But early in the afternoon of the 24th Pliny's mother pointed out to her brother an enormous cloud in the shape of a pine tree which changed colour continuously. The admiral was studying the cloud, not knowing its cause, when a call for help arrived from Rectina, the wife of Tascio, who lived at the foot of Vesuvius. She found herself hemmed in by the eruption, with only the sea offering a possible route to safety. The admiral ordered the entire fleet to put to sea, intending to take off as many as possible of the numerous inhabitants along that part of the coast. During the crossing the ships were covered in the ash pouring out of the volcano, which as they drew nearer the coast became hotter and denser, containing flaming pumicite and lapilli. The force of the eruption was such that the ships could not land and had to sail on to the port of Stabiae, four miles to the south of Pompeii. Here Pomponiano, a local man of substance who was a personal friend of the admiral, had loaded his goods onto boats ready to make his escape by sea as soon as the onshore wind, which had brought the fleet across the Bay, should drop and make it possible to embark. In the meantime the admiral went ashore and had dinner as a guest of Pomponiano, continuing to scrutinise the spectacle that, with nightfall, had become truly awesome. There was no let up in the shower of ash, which built up in drifts in the central courtyard of the house, forcing the diners to leave the dining room before they were trapped inside. What is more, the tremors went on unabated, shaking the buildings to their foundations, and everybody chose to stay out in the open, covering their heads with cushions to protect themselves from the storm of scorching particles, rather than risk being buried under falling masonry.

At dawn on August 25th the light of the sun was unable to penetrate the thick veil of soot hanging over the never-ending eruption, while the conditions of wind and sea continued to make escape impossible. The admiral was overcome by the choking ashes mixed with sulphurous exhalations, and he died along with many other inhabitants of Pompeii. The contorted corpses of some of them have been restored to us in plaster casts, bringing home the excruciating suffering of a death by suffocation from fumes. The emperor Titus set up a magistracy to deal with the aftermath of the catastrophe. We do not have much information about what this achieved, apart from some fragments of epigraphs dating from the years 80-82 AD. Findings during the excavation of the site suggest that the survivors attempted several times to dig down through the debris and retrieve something of what had been abandoned in the

*Villa of the Mysteries, detail
from the life-size painting.*

houses. In general, we know that the whole of the paving of the Forum was removed, together presumably with the bronze statues which had stood in the square, and this probably indicates that working parties removed materials that could be reused elsewhere.

In spite of these initiatives, the city passed into total oblivion, such that even its name was forgotten. In the late 1500s two inscriptions in Latin were found during the construction of a canal for the distribution of water from the Sarno river, but it was still premature to identify their origin. Even in the first years of the excavations, which began in 1748, no one was quite sure whether the site was Stabiae or Pompeii, until, as Winckelmann recorded, an inscription came to light which proclaimed unequivocally the name of the Pompeiian colony.

Since then more than two centuries have gone by, and millions of visitors have come to experience one of the most significant legacies of the ancient world, carrying away with them sensations and reflections which may indeed be of use in charting their future lives.

ITINERARIO · A
ITINERARY A

Da Porta Marina
alla Casa dei Ceii

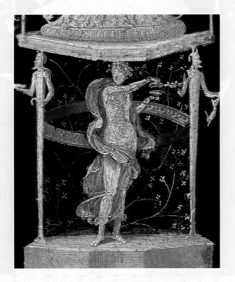

From Porta Marina
to the House of the Ceii

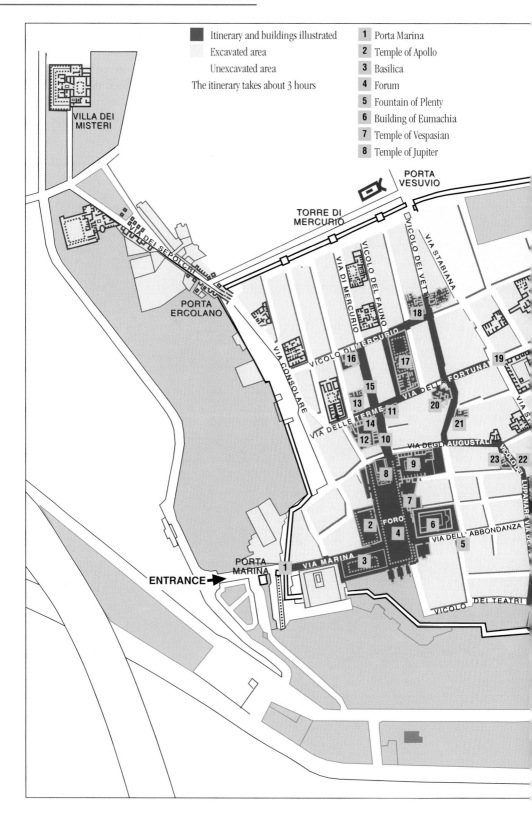

Itinerary and buildings illustrated
Excavated area
Unexcavated area
The itinerary takes about 3 hours

1 Porta Marina
2 Temple of Apollo
3 Basilica
4 Forum
5 Fountain of Plenty
6 Building of Eumachia
7 Temple of Vespasian
8 Temple of Jupiter

VILLA DEI MISTERI

PORTA VESUVIO

TORRE DI MERCURIO

VIA DEI SEPOLCRI

PORTA ERCOLANO

VICOLO DEI VETTI

VIA STABIANA

VICOLO DEL FAUNO

VIA DI MERCURIO

VIA CONSOLARE

VICOLO DI MERCURIO

16 17 18

VIA DELLA FORTUNA 19

15
13 11 20 VIA S
VIA DELLE TERME 14 21
12 10

VIA DEGLI AUGUSTALI 23 22

9
8

7 VICOLO DE LUPANARE VIA DE

2 FORO 6 VIA DELL' ABBONDANZA
4 5

PORTA MARINA 1 VIA MARINA 3

ENTRANCE ►

VICOLO DEI TEATRI

9 Macellum	**17** House of the Faun	**25** Doric Temple
10 Celebratory arches	**18** House of the Vettii	**26** Large Theatre
11 Temple of Fortuna Augusta	**19** Via di Nola	**27** Quadriporticus of the Theatres
12 Forum Baths	**20** House of the Ancient Hunt	**28** Small Theatre (Odeion)
13 House of the Tragic Poet	**21** Bakery	**29** Temple of Isis
14 Thermopolium	**22** Vicolo del Lupanare	**30** House of Menander
15 Via di Mercurio	**23** Brothel	**31** House of the Ceii
16 House of the Small Fountain	**24** Triangular Forum	

PORTA
DI NOLA

VIA DI NOLA

VIA DI NOLA

PORTA
DI SARNO

VICOLO DI TESMO

VIA DELL' ABBONDANZA

VIA DELL' ABBONDANZA

VIA DI NOCERA

ANFITEATRO

31

PALESTRA
GRANDE

TEMPIO DI ISIDE

30

VIA STABIANA

28

PORTA
NOCERA

27

PORTA DI STABIA

**AMPHITHEATRE
ENTRANCE**

The name is modern and indicates that the road passing through this gate led down to the sea. The gate originally had two arches (one for pedestrians only), subsequently made into one barrel vault in *opus cementitium* (a compound of mortar and stones).

When Pompeii became a Roman colony in 80 BC (p. 22), the city walls no longer served their defensive purpose and in some places were built over as citizens put up new houses. In this section a bathing establishment was built on the left just outside the gate and sumptuous residences were laid out on terraces with fine views overlooking the sea, then much closer to the city than it is today.

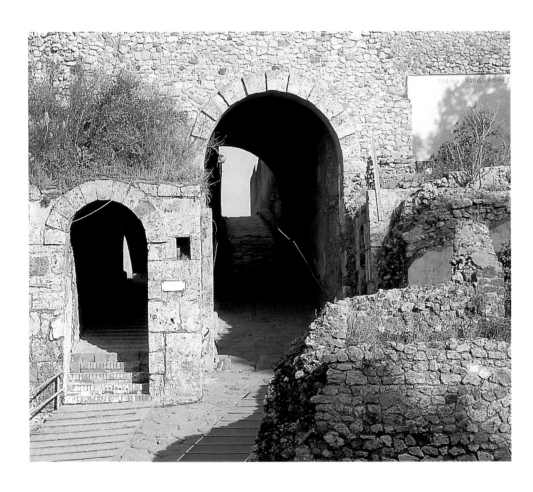

Originally this was the most important religious building in the city. Only a few fragments of decorations in terracotta remain from its earliest phase, dating from 575-550 BC. It took on its definitive aspect during the major renovation carried out in Pompeii in the 2nd century BC. This is when both the portico in tufa with its two tiers of columns and the temple were put up, combining Greek elements (such as the colonnade surrounding the cella) and Italic features (the high dais reached only by a central flight of stairs).

The façade of the temple is flanked by bronze statues of Apollo and Diana arrayed as archers (the originals are in the Naples Museum). The column with the sundial was added in the time of Augustus.

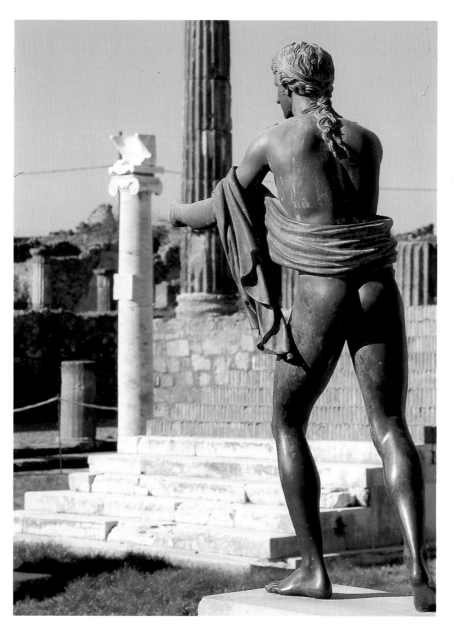

Dating from the second half of the 2nd century BC, it is the oldest building of its kind to have come down to us and was put up as part of the building programme to provide the city with public monuments. It housed law courts and business activities. Its central nave and two aisles were originally covered by a sloping roof supported by the massive central columns and semicolumns in the upper section of the side walls. At the far end is the tribunal, where the magistrates sat, reached by wooden steps. Some traces of the original plasterwork in the "first style" have survived (see C1, p. 119).

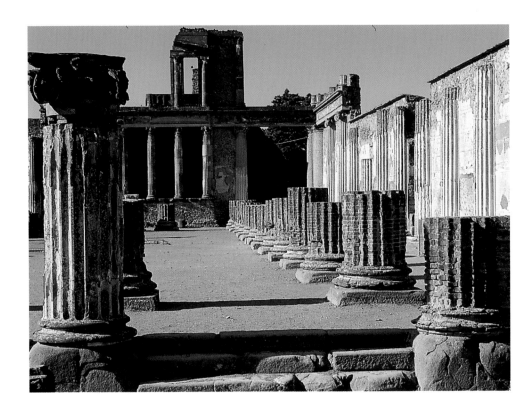

Situated at the junction of the two main streets of the first urban development, which occupied only part of the area within the city walls (see A22, and pp. 16,18). It was embellished for the first time in the public works programme undertaken in the 2nd century BC, when the portico with its double colonnade in tufa was built, together with the other important monuments on this site: the Basilica, Temple of Jupiter and Macellum. In the Imperial age new buildings were put up on the eastern side, previously occupied by a row of shops, and work was begun on repaving the square and rebuilding the colonnade in white limestone. In common with building programmes in other cities, the Forum was given its definitive appearance to celebrate the Imperial household during the 1st century AD (A4, A6, A10).

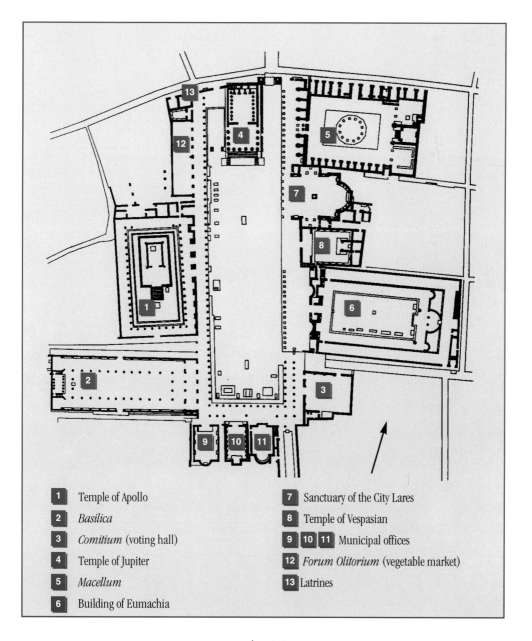

1 Temple of Apollo		**7** Sanctuary of the City Lares	
2 *Basilica*		**8** Temple of Vespasian	
3 *Comitium* (voting hall)		**9 10 11** Municipal offices	
4 Temple of Jupiter		**12** *Forum Olitorium* (vegetable market)	
5 *Macellum*		**13** Latrines	
6 Building of Eumachia			

The main square in the city, closed to wheeled traffic and lined with the most important religious, political and commercial buildings. The numerous pedestals seen in the portico bore statues of the leading citizens, while the monumental plinths along the south side, in front of the municipal offices, displayed statues of the Emperor riding in a quadriga and members of the Imperial family. A short way in front stands a base for an equestrian statue, while at the centre of the western side there is a dais for orators. Neither the statues which stood in the square nor those that decorated the buildings round it have been found; it seems likely that they were salvaged by survivors of the eruption.

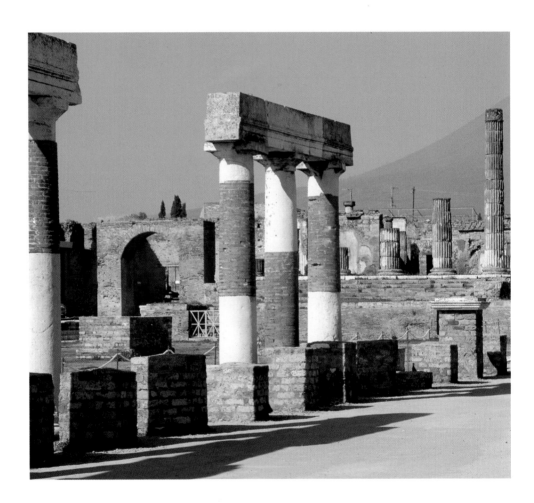

The Via dell'Abbondanza, closed to chariots in the section leading into the Forum, takes its name from this public fountain bearing a relief of the Concordia Augusta symbolised by a horn of plenty.

This is one of 43 fountains known to us, erected after the construction of the aqueduct and mains water supply in the Augustan age (see C10). They were generally placed at street corners and made from a large block of volcanic rock. This one is very unusual in being of fine white limestone.

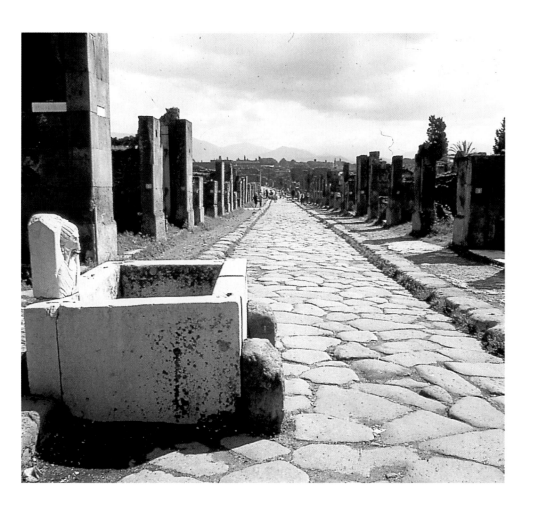

Built in the reign of Tiberius by the priestess Eumachia, who presided over the guild of fullers *(fullones:* see C5). The exterior as we see it, in *opus lateritium* faced with marble panels (since removed), is the result of restoration work following the earthquake in 62 AD. The façade had a spacious portico in front of it with plinths for statues of famous personages, and four recesses containing statues of Romulus and Aeneas (one of the celebratory inscriptions remains *in situ*) and, probably, Caesar and Augustus.

The overall scheme is clearly a tribute to the dynasty of the Julius and Claudius families. The entrance gateway is framed by a finely wrought marble relief with acanthus spirals sheltering birds and insects, recalling analogous designs in Rome, for example on the Ara Pacis.

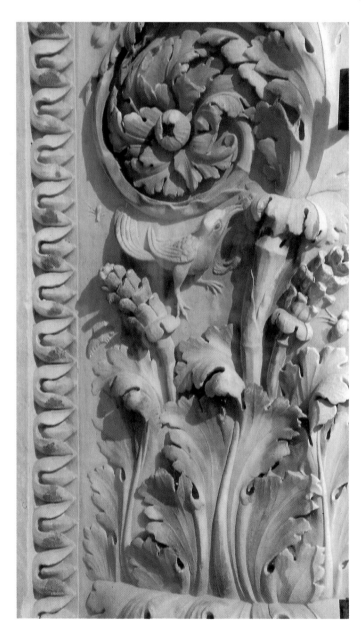

The interior comprises a large open courtyard surrounded by a portico with Corinthian columns and a cryptoporticus. In the exedra in the end wall stood a statue of the Concordia Augusta, and in the side recesses statues of members of the Imperial family (possibly Tiberius and Drusus).

In a recess in the cryptoporticus behind the exedra stands a statue of Eumachia herself (the original is in the Naples Museum). While there is no doubt about the building's celebratory intent, its actual purpose is less clear: it may have been a wool market and the headquarters of the fullers' guild. In the room to the right of the entrance a large vat had been set up into which people could urinate from the top of a flight of steps.

Urine was collected by fullers for its bleaching properties (see C5), and its use was taxed by the emperor Vespasian.

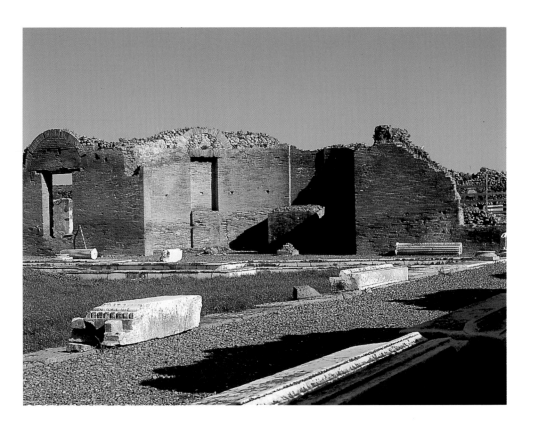

Built at the beginning of the 1st century AD to celebrate the Imperial cult. Here too the exterior in *opus lateritium* faced with marble panels dates from the restoration work following the earthquake in 62 AD. Inside there was a narrow portico leading into the open courtyard with a sacrificial altar in the middle. The shrine, in the form of a miniature temple, was set up against the back wall with steps leading up from both sides, four columns along the front and a statue of the Emperor (see A4, p. 36).

Altar

The white marble altar bears a scene depicting the sacrifice of a bull, customary in the Imperial cult. In the background a small tetrastyle temple can be seen, possibly in imitation of this building. The scene may in fact represent the sacrifice held to inaugurate this temple, while the other three faces show objects associated with the Imperial cult.

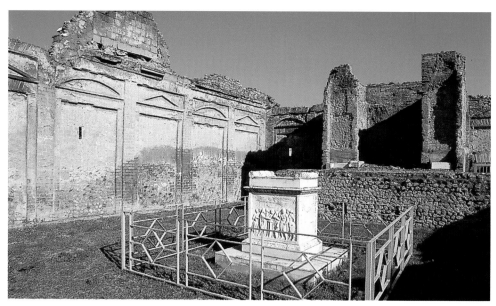

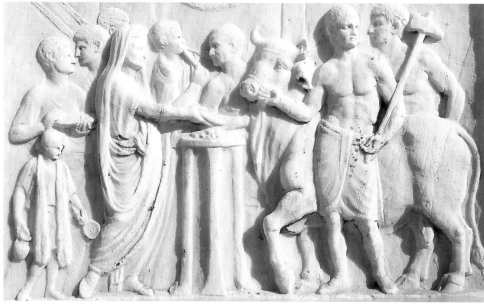

Dating from the first elaboration of the Forum area in the 2nd century BC, it was transformed in the years following the founding of the Roman colony in 80 BC into a Capitolium dedicated to the cult of the Capitoline Triad: Jupiter, Juno and Minerva. It is in the Italic style with a colonnade leading to the cella raised on a high dais reached by a central flight of stairs. The cella had two rows of double columns dividing it lengthways, where there is a colossal head of Jupiter from the period of Sulla. The dais, flanked by pedestals for equestrian statues, was rebuilt in the reign of Tiberius, which is also when the main altar was moved out into the square, in front of the temple. The floor of the cella, as in the temple of Apollo, was made of rhomboid-shaped coloured marble arranged to imitate cubes seen in perspective.

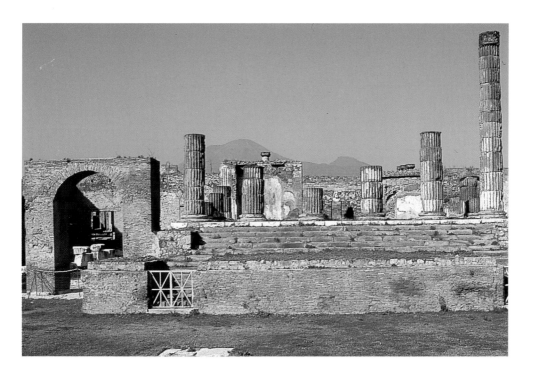

Entrance

The word *macellum* means market in Greek. There was a market on this site in the 2nd century BC, which was rebuilt during the first half of the 1st century AD, and further work was carried out following the earthquake of 62 AD. Its structure is comparable to that of other examples of *macellum* known to us from Roman times. As in the building of Eumachia, there are plinths for statues of illustrious citizens in the portico in front of the entrance. The two fine capitals on Corinthian columns on either side of the entrance, decorated with chimerae, were taken from the necropolis of the Porta Ercolano.

Interior

Inside there is a courtyard surrounded by a colonnade, with a row of shops on the southern side. The twelve slabs set up in the middle supported the wooden poles that held up a circular sloping roof. From the quantity of fish bones found, this must have been the area of the fish stalls. In the middle of the far wall there was a shrine (*sacellum*) containing a statue of the Emperor, only fragments of which survive. Two whole statues were found (now in the Naples Museum), possibly of members of the family who had contributed to restoring the building. The area on the right was probably where meat and fish were sold, and that on the left may have been used for banquets in honour of the Emperor.

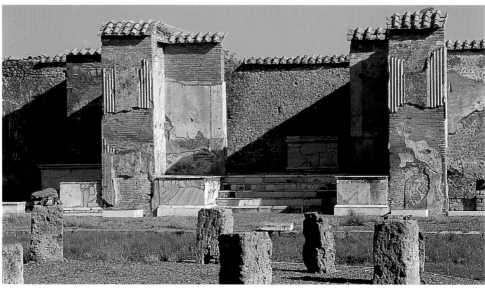

Paintings

On the northeastern wall it is still possible to see part of the plasterwork with frescoes in the "fourth style" which came into vogue in Pompeii and elsewhere in the middle of the 1st century AD. The hallmark of this style (see C6, p. 132) is the division of the wall into fascias and panels, separated by architectural fantasies, within which are depicted figures in isolation or scenes from mythology (here Medea mourning the death of her children, Io and Argos and Ulysses recognised by Penelope). Above them are panels in the vernacular style with still lifes. The highest fascia in the "fourth style" is given over to architectural fantasies.

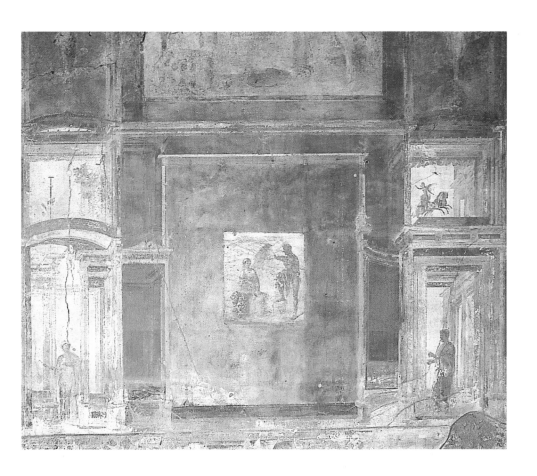

The transformation of the square to celebrate the Imperial dynasty of Augustus and his successors was completed by the celebratory arches built in *opus lateritium* faced with marble. Two were built either side of the temple of Jupiter, but only the one on the left still stands. It is likely that the other one, probably dedicated to Nero, was destroyed in accordance with the *damnatio memoriae* proclaimed for that Emperor. The arch situated at the far end of the temple of Jupiter, at the northeastern entrance to the Forum, had two statues (possibly Nero and Drusus) in the recesses on the southern side and two fountain basins on the opposite side. Further on, at the beginning of Via di Mercurio, stands another arch, known as the "arch of Caligula", which bore an equestrian statue.

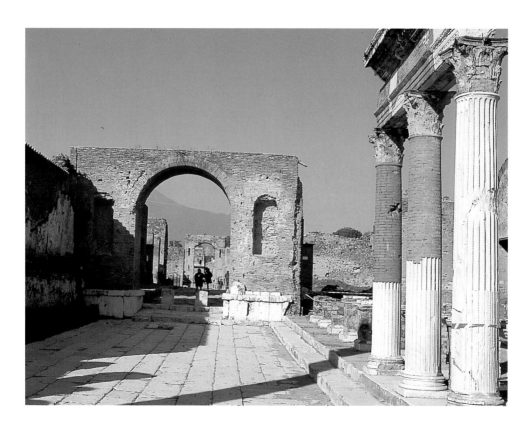

This temple, with its façade of Corinthian columns and capitals in white marble, was erected by the duumvir Marcus Tullius at his expense and on land he owned in honour of Augustus (see p. 26). Inside the sacellum, on a raised dais at the far end, stood the statue of Fortuna Augusta, while lateral niches contained statues of the Imperial family and perhaps also of Marcus Tullius. Temples dedicated to the Fortuna Redux of Augustus were put up in Rome and other cities following the Emperor's triumphal return from an expedition in either 19 or 13 BC.

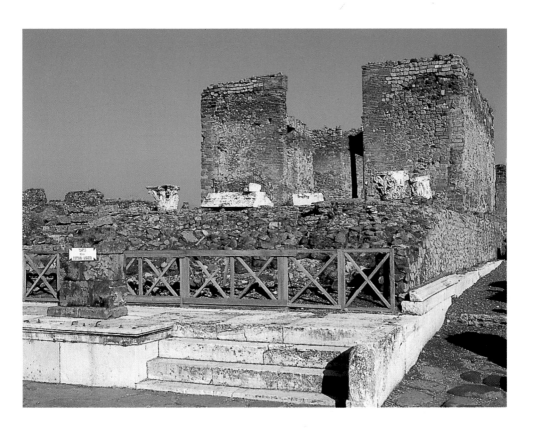

VII, 5, 24

These baths were built with public funds soon after the installation of the Roman colony, to the same design, although on a slightly smaller scale, as the older Stabian Baths (see C6). Two separate areas, on either side of the furnaces, were for use by men and women. The former is larger and more elaborate, with the usual sequence of rooms: first the changing room, then a round room with the cold bath, followed by the warm room and finally the hot room. The palaestra, surrounded by a colonnade, could be reached either from the men's changing room or by an entrance off Via del Foro, but not from the women's section. The changing room, with a marble bench running round the walls, was not provided with recesses for depositing clothes, and presumably these were left in piles on wooden benches which fitted into the slots clearly visible in the walls.

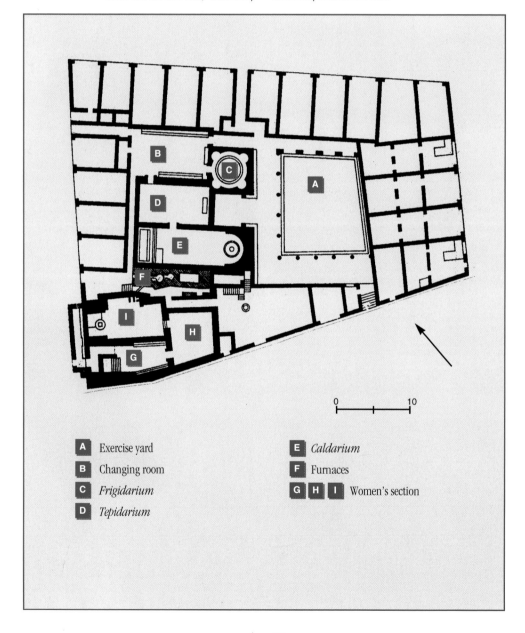

A	Exercise yard	**E**	*Caldarium*	
B	Changing room	**F**	Furnaces	
C	*Frigidarium*	**G** **H** **I**	Women's section	
D	*Tepidarium*			

Tepidarium

The warm room (*tepidarium*) was not provided with the sophisticated heating system used in the hot room. Heat came from a large bronze brazier bearing the emblem of a cow, proclaiming it as a gift from the wealthy manufacturer M. Nigidius Vaccula. The telamons placed between the alcoves where oils and bathing accessories were probably kept date from the earliest phase of the building, whereas the plaster relief decoration on the ceiling, with its geometrical partitions and mythological figures, was added during restoration work following the earthquake of 62 AD. The myths represented are Eros with his bow, Apollo riding a griffin and Ganymede carried off by the eagle, destined for Jupiter, who had fallen in love with him and who made him the cupbearer to the gods on Olympus.

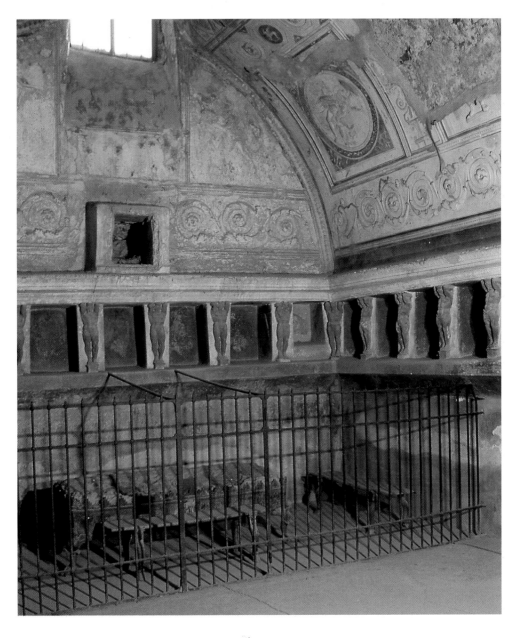

Caldarium

As was customary, the hot room (*caldarium*) contained a pool and a large basin with a jet of cold water playing continually for the bathers to cool off. The inscription set in bronze into the rim of the basin proclaims that this was contributed, using public funds, by the duumvirs Gn. Melissaeus Aper and M. Staius Rufus in the reign of Augustus (see C3). Here we see the heating system that came into use early in the 1st century BC. The mosaic floor was built up on brick stacks (*suspensurae*) and thus raised above floor level. The hot air produced in the adjacent furnaces (note the duct near the pool) passed under the mosaic floor and up the air ducts built into the walls so that the whole room was enveloped in hot air.

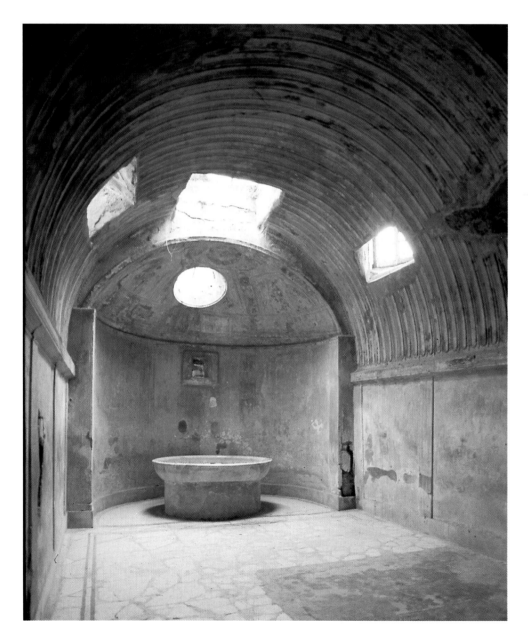

VI, 8, 5

This was the setting for Bulwer Lytton's classic *The Last Days of Pompeii*. On its threshold is the famous mosaic of a dog on a chain and the words CAVE CANEM, "Beware of the dog". Such a warning is to be found in other houses, either in mosaic or in a wall painting, and also in literary sources, such as the uproarious episode in Petronius's *Satyricon* in which the protagonist is scared out of his wits by a painting of an outsize guard dog.

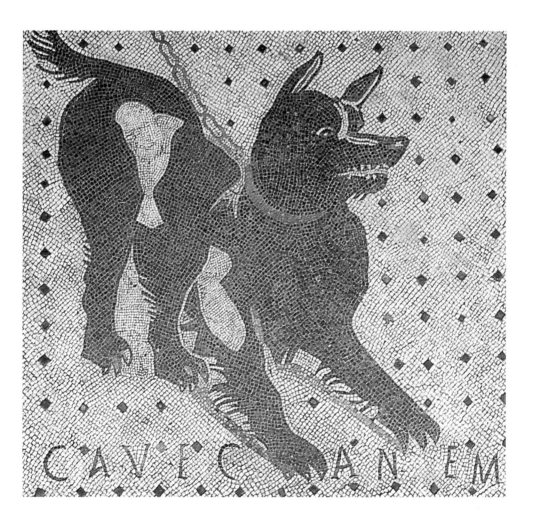

VI, 8, 8-9

There were many such "places for hot meals" since it was common for people to eat out for their midday meal. In its simplest form it comprised a single room, even quite small, opening directly off the street, with a stonework counter into which were set the urns (*dolia*) containing the fare on offer. Sometimes customers could eat sitting down rather than at the counter, in one or more rooms at the back. It was not unusual for there to be rooms upstairs for more carnal pleasures.

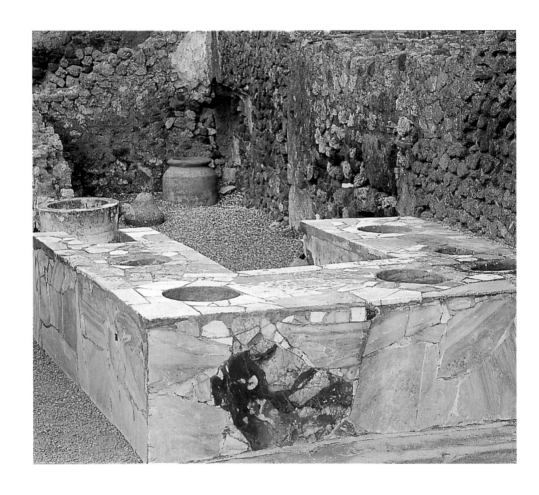

This was the main north-south route through the original settlement, leading out of the city walls by a gate that was subsequently blocked up when the fortified towers were built (see C11, p. 148). It takes its name from the image of Mercury sculpted on the public fountain set up in this street. Not far from the city's administrative centre, it became a principal artery of the residential quarter known as Regio VI.

Thus it has few shops or workshops and is lined with the wealthy dwellings of the upper classes, some still with their solid walls in massive blocks of tufa or limestone.

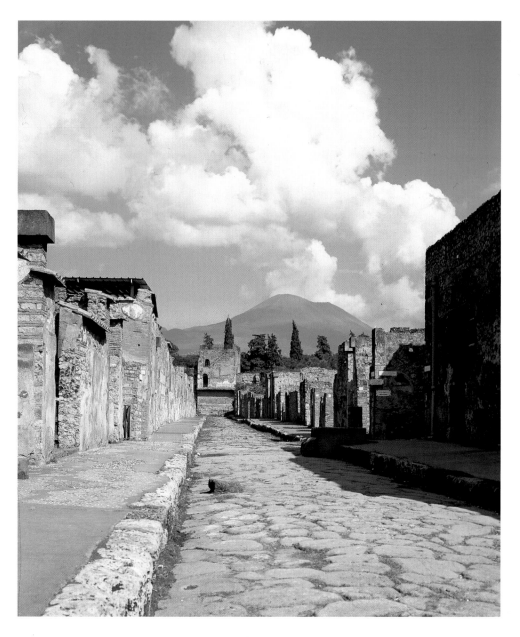

VI, 8, 23

This goes back to the Samnite era, and is an example of an "atrium house". Such houses, belonging to citizens from the upper classes, were laid out along an axis of entrance (*fauces*)-atrium-tablinum. These were public rooms, since the owner would receive his clients in the tablinum, and they had to be sumptuously built to reflect his social standing. The linear progression drew the gaze of whoever entered, or indeed of passers by, through the atrium to the tablinum, revealing at once the degree of affluence of the householder. The atrium was at the centre of the house, with most of the other rooms leading off it. The roof was built sloping inwards so that the rainwater drained into a pool in the centre (*impluvium*) and ran off into a tank below, where it could be drawn off from wells.

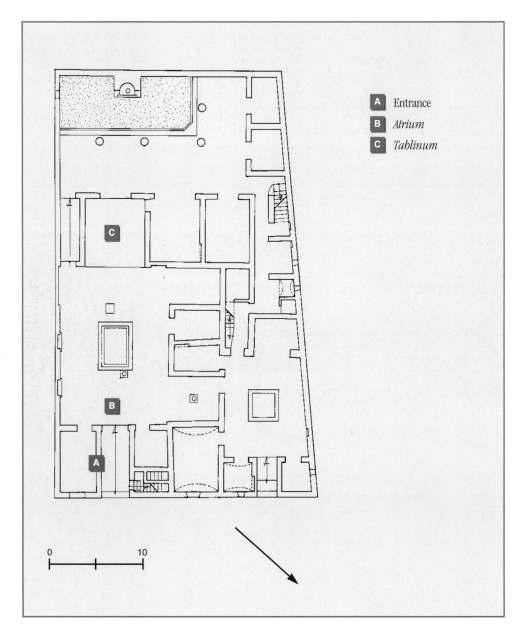

A Entrance

B *Atrium*

C *Tablinum*

0 10

Garden

Originally, beyond the tablinum there would have been a simple garden (*hortus*). From the 2nd century BC onwards this was extended, space permitting, to create an elaborate garden surrounded by a peristyle. The ready availability of water following the construction of the aqueduct (see C10) made it possible to build fountains decorated in mosaics of vitreous paste and seashells and embellished with statues, set against the far wall of the garden. The fountain-cum-nymphaeum was characteristic of country villas, and came to be imitated in urban dwellings. In this case the fresco on the walls is a magnificent landscape featuring seaside and rustic constructions.

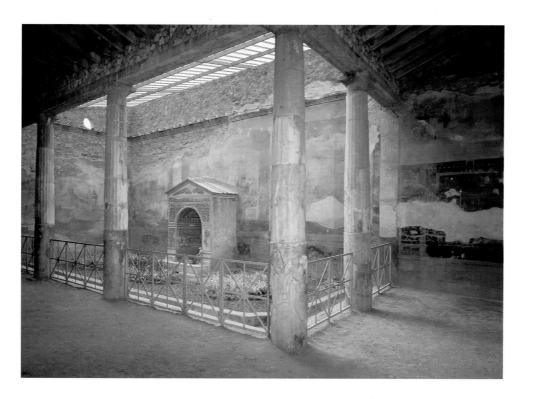

VI, 12, 2

The largest house in Pompeii, covering 3,000 square metres and occuping a whole Insula. It was laid out between 180 and 170 BC with two atria, a peristyle and a spacious *hortus*, which later in the century was converted into a second peristyle. The entrance to the left leads to the public area of the house, with the canonical sequence of *fauces-atrium-tablinum*, while to the right one enters the private quarters. Here the atrium is one of few to have a roof supported by four columns (tetrastyle); in it were found cupboards and storage space for vases. Opening off the corridor running alongside the first peristyle are the stables, latrine, small baths (with tepidarium and caldarium) and kitchen.

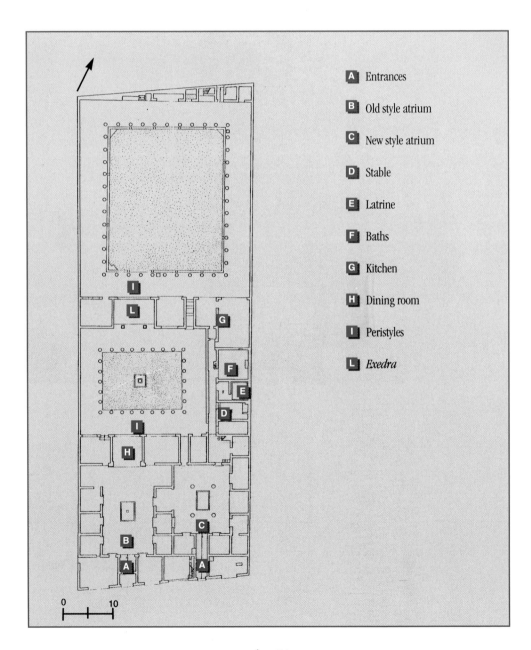

A Entrances

B Old style atrium

C New style atrium

D Stable

E Latrine

F Baths

G Kitchen

H Dining room

I Peristyles

L *Exedra*

0 10

A • 54

Entrance

The Latin greeting HAVE on the threshold, introduced after the arrival of Sulla's colony, may have been a deliberate gesture on the part of the householder to affirm the Romanisation of the city. In the entrance there is a good example of wall decoration in the polychrome "first style" (see C1, p.119), crowned by two temple façades in miniature complete with columns. The flooring, comprising triangular tiles of coloured marble (*opus sectile*) typical of public buildings, was embellished on the threshold by a mosaic (now in the Naples Museum) depicting a garland and masks from the tragic drama. Thus right from the entrance there was no mistaking the singular character of this dwelling, which had more in common with the Hellenistic "palaces" and the residences of the Roman aristocracy than with the houses of the local upper classes.

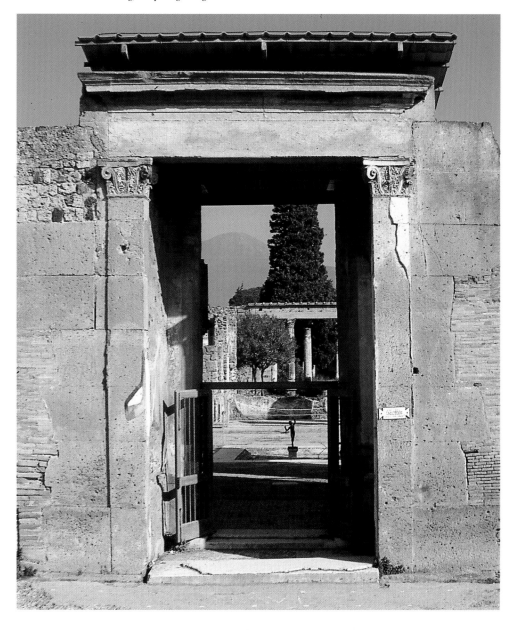

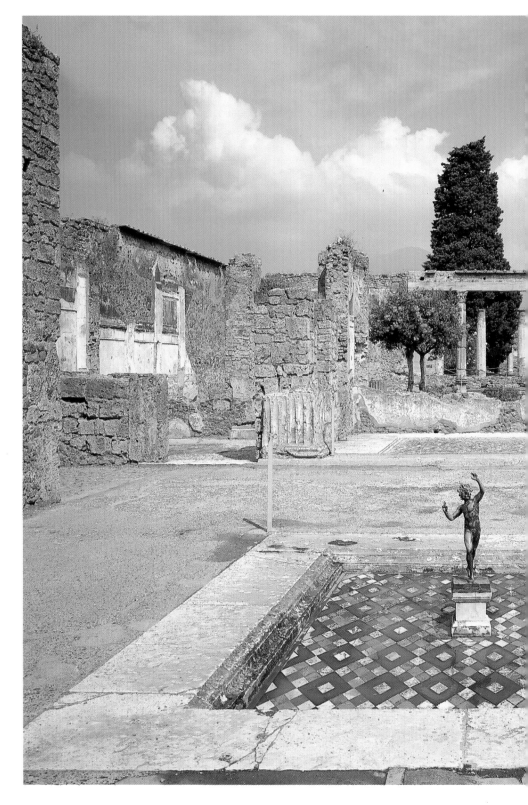

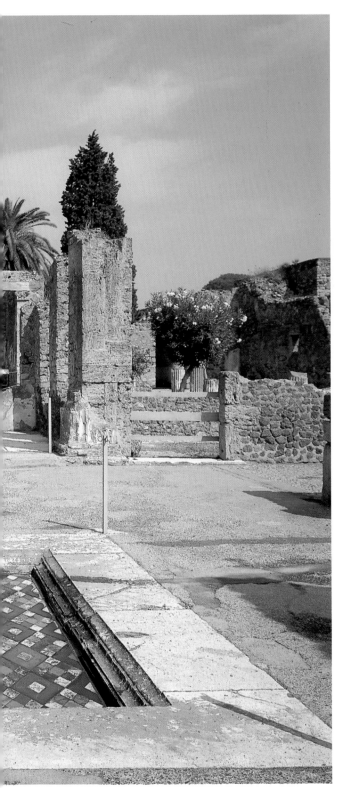

Atrium

The large atrium is in the most common style (*tuscanico*) with its roof not supported by columns. In the centre there is the impluvium; its floor resembles that of the entrance, in lozenge patterns of coloured marble. The bronze statue of the faun, from which the house was named since the identity of the owner remains a mystery, was made in Alexandria at the end of the 2nd century BC (the original is in the Naples Museum). The floors of the rooms off the atrium (bedrooms, dining room and living room) have mosaic pictures set into them (emblemata, see A 30) depicting homely scenes appropriate to the domestic quarters (a cat trapping a bird, doves, a satyr and nymph in erotic embrace). Some of the rooms conserve traces of wall decoration in the "first style" (see C1, p. 119).

Tablinum

The most prestigious of the reception rooms, the tablinum, is also paved with tiles of coloured marble, like the entrance and impluvium, but in this case they create the effect of cubes seen in perspective, deliberately modelled on the flooring in the cellae of the temples of Apollo and Jupiter. In this particularly well-to-do Pompeian house, which remained largely unaltered through to 79 AD, we can see the distinction between the more homely and inventive floor designs in the domestic quarters and the formal schemes imitating public monuments in the reception rooms. The climax of the house came in the tablinum, where the householder received his clients. It was strikingly framed between columns of the exedra set at the far end of the peristyle beyond.

Garden and exedra

Beyond the private quarters and the reception rooms, two large gardens open out, each with its peristyle. They are separated by a succession of rooms serving various purposes, notably the exedra, situated so as to crown the view through from the entrance to the tablinum. It was the most ornate structure in the building, adorned with Corinthian columns and capitals in painted plasterwork. The flooring here was the grandiose mosaic (now in the Naples Museum) depicting the battle between Alexander the Great and the Persian king Darius, based on the famous painting by Philoxenes of Eretria which was contemporary with Alexander's conquests in Asia. The presence of this and other mosaics evoking the Alexandrine world and his conquest of Asia suggests a possible link between the householder and the Macedonian sovereign.

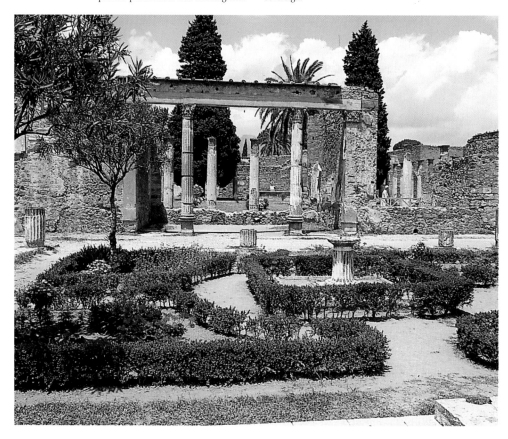

VI, 15, 1

From electoral propaganda and, above all, from two signet rings found here, we know the names of the two house-holders: Aulus Vettius Conviva and Aulus Vettius Restitutus, freedmen who had a flourishing business. The house originally had two atria, but in the middle of the 1st century AD it was sub-stantially altered. In particular the tablinum was eliminated so that one passed directly into the peristyle, which by this time had generally become the centrepiece of well-to-do houses. From the peristyle there was access to the dining room (*triclinium*), living rooms and a small apartment, built round a courtyard, which may have been the women's quarters.

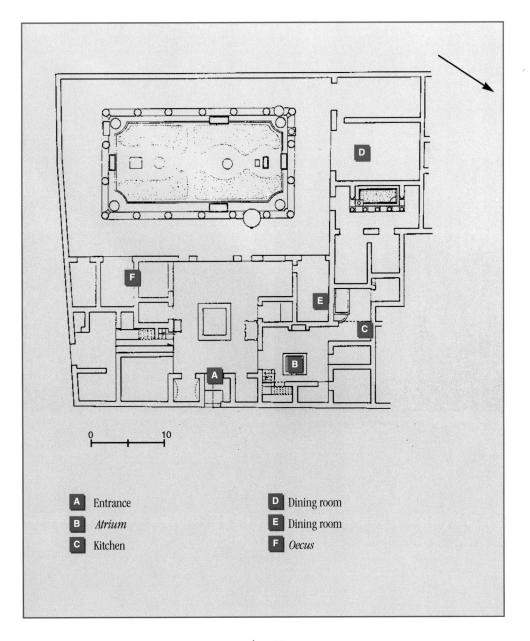

0 10

A Entrance	D Dining room
B *Atrium*	E Dining room
C Kitchen	F *Oecus*

Entrance

At the entrance the visitor is greeted by a painting of Priapus, the god of fertility, with an outsize phallus placed on one pan of a pair of scales and a moneybag as its counterweight. This image served both to combat the evil eye and as a talisman of prosperity. On the adjacent wall is a painting of a sheep with the attributes of Mercury, the god of commerce. Both paintings were supposed to be propitious for the activities of the householder and were expressions of an uninhibited popular art which contrasts with the rigid decorative schemes found elsewhere in the house.

Lararium

The smaller of the two atria, surrounded by the servants' living and working quarters on two floors, is dominated by the large lararium in the form of an aedicule . The pediment, supported by Corinthian semicolumns, is decorated in plasterwork with objects associated with the cult. On the back wall, as was customary, are paintings of the two Lares (guardians of the family and hearth) and between them the Genius of the householder making a sacrifice. Underneath is the "agathodemon", a beneficent spirit in the form of a snake (see C1, p. 121).

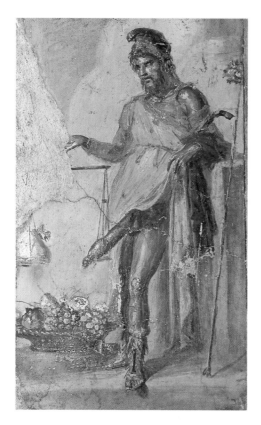

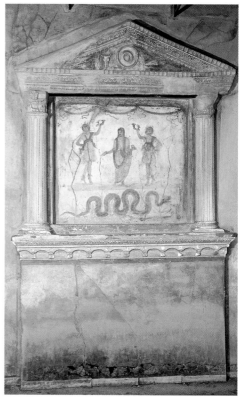

Kitchen

On the cooking range in the kitchen the iron grill and bronze pots and pans stand just as they were found. The alcove in the range was where firewood was kept, while the fire itself was tended on top of the range. Breakfast and lunch (the latter often eaten out, see C2, A14) were simply snacks, while the main meal of the day was in the evening, taken reclining on couches in the triclinium. A full dinner consisted in antipasto (*gustatio*) with eggs, vegetables, sea food and honied wine, followed by *prima cena*, the meat, fish and vegetable course in which a number of dishes might be served, and then *secunda cena* with dessert and fresh and dried fruit. Wine was generally diluted and flavoured. One particularly common ingredient found in many recipes was *garum*, a sauce made by macerating fish in brine.

Room with Priapus

Opening off the kitchen was a small room decorated with erotic scenes, painted in the simple, direct style that characterised popular art. Here is also displayed a sculpture of Priapus which was found in the kitchen but probably stood in the garden since it was actually a fountain, the water jetting out of the god's phallus.

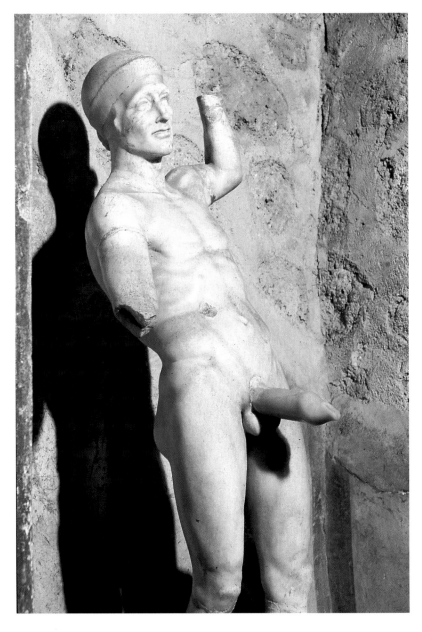

Atrium

The main atrium is decorated in the "fourth style" and is of particularly high quality, with scenes of children making sacrifices, cupids riding chariots or animals and ornate candelabras. The compluvium still has its terracotta waterspouts in the form of lion's heads from which rainwater poured into the pool below. Placed against the side walls were two wooden strongboxes with fittings in iron and bronze. Although this was obviously an affluent household, the absence of the tablinum takes away that emphasis on social standing which characterised the "atrium houses" of the upper classes (A16, p. 52, A17).

Garden

Thanks to the ready availability of water from the aqueduct, the garden was adorned with numerous small sculptures from which water cascaded into basins that are still *in situ*. Such ornamentation and *jeux d'eau* are perhaps taken to excess here, given the limited dimensions of the garden. They reflect the fashion, which caught on in the first part of the Imperial age, for imitating in the confined space of town houses the verdant vistas and free-standing sculptures of sumptuous country villas (see B2).

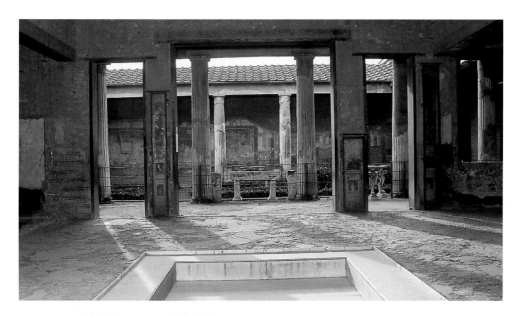

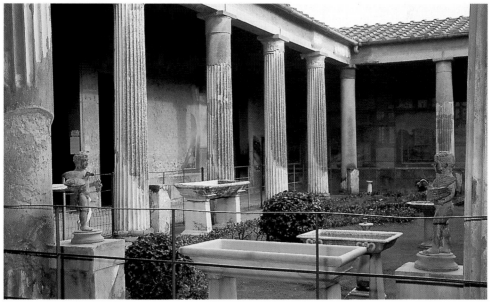

Hall

The hall opening off the north side of the peristyle is perhaps the best known example of wall painting on account of its large panels in Pompeian red (obtained from the mineral cinnabar, also used in other Roman sites) and above all the frieze that runs right round the walls. This represents sports (archery, chariot races) and crafts (perfumery, goldsmithery, laundering and so on) enacted by cupids and *psychai*. The frieze originates in Hellenistic culture, but it reflects Roman tastes in its scenes of everyday life and high degree of realism. It has been suggested that the scenes of viticulture may reflect one of the activities, if not the principal one, of the Vettii, and the conjecture is strengthened by the wine jar shown on the signet ring belonging to one of the two merchants (A18, p. 59).

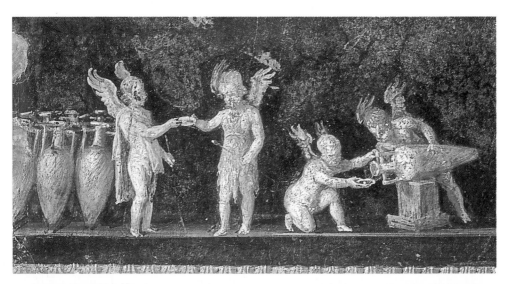

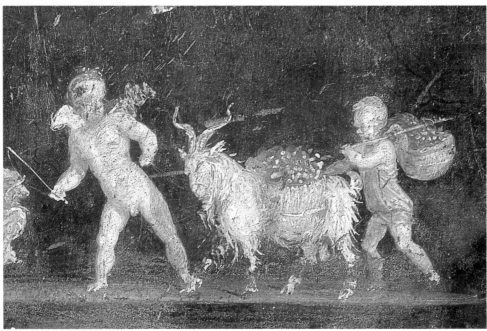

Living room

The living room (*oecus*) and dining room have the most beautiful and best conserved wall decorations in the "fourth style" (see A9, p. 43). Above the dado, in the centre of the panels dividing up the central registers, the paintings are predominantly mythological: Hercules strangling the snakes, Pentheus torn to pieces by the Bacchantes and Dirce tied to the bull. They were generally copies of celebrated Greek originals and were seen as authentic art collections, enhancing the tone of the house and presenting its owner as an art-lover. From the stylistic point of view, the skill and inventiveness of the artists are to be seen above all in the ornaments and subsidiary motifs.

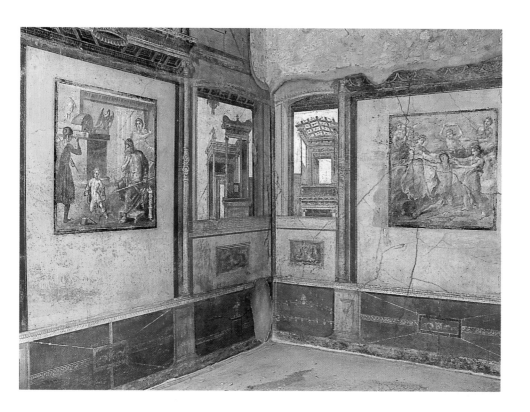

The other main artery of Pompeii, running east-west as the continuation of Via delle Terme and Via della Fortuna (see B1). It went out through Porta di Nola, and is believed to have led inland to that city, although these names are modern day conventions. The large blocks of stone placed across this and other streets were to make crossing on foot easier. The lack of a complete system of drains meant that when the drainage tanks in private houses and the public fountains overflowed, the water ran down the streets which, especially in wet weather, must frequently have been awash.

VII, 4, 48

Redecorated in the "fourth style" in the second half of the 1st century AD, it nonetheless conserves almost intact its original layout from the Samnite period, on the typical pattern of the "atrium house". The entrance, with its façade in blocks of tufa, cubic capitals and booths for stallholders, leads into the atrium, with bedrooms and living room grouped round it and, at the far end, the dining room and tablinum. The decoration of the second bedroom (*cubiculum*) on the right is fairly well preserved, with paintings depicting Leda possessed by Jupiter as a swan and Venus fishing and medallions with busts of Jupiter, Diana, Apollo and Mercury.

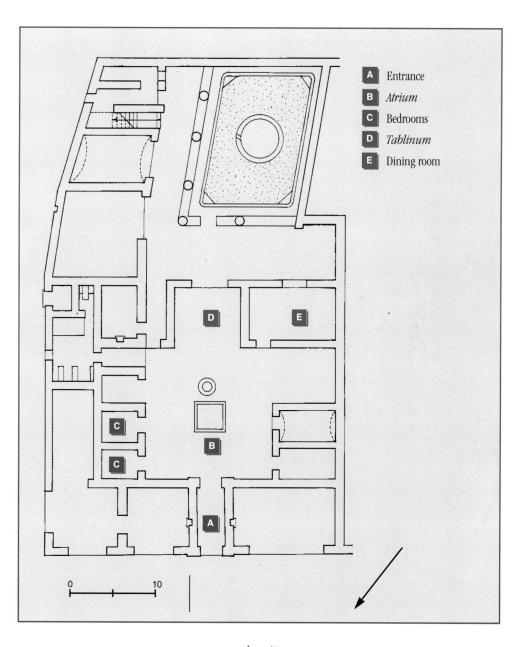

A Entrance
B *Atrium*
C Bedrooms
D *Tablinum*
E Dining room

0 10

Garden

This name derives from the scene painted on the rear wall of the garden, unfortunately in poor condition. It shows a hunt for wild animals in a mountainous landscape, and is another example of how the owners of small town houses liked to allude to the spacious country villas with their scope for hunting (see C8, p. 141).

Tablinum

The tablinum was not enclosed in any way, opening off the atrium and onto the garden at the back. Its wall decoration comprises the usual dado, in this case made to imitate marble panelling, surmounted by a delicately wrought predella showing landscapes on the River Nile and cupids hunting. The middle register is subdivided into skyblue panels which imitate carpets billowing in the wind. The pictures which originally occupied the centre of each panel have been removed.

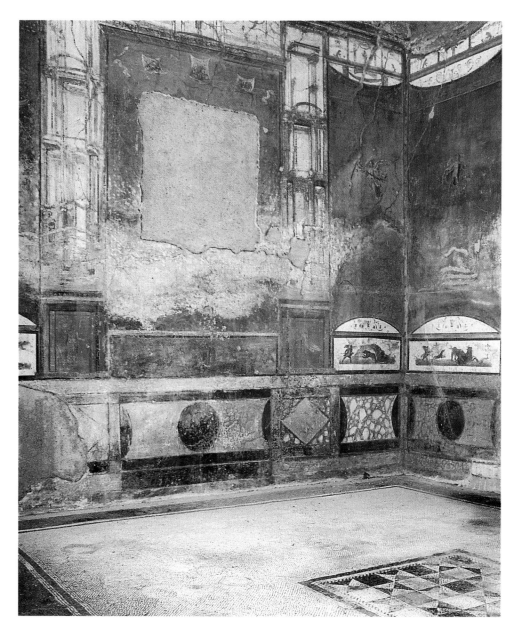

VI, 2, 22

It adjoins the house of Popidius Priscus, a member of one of the oldest and most important families in Pompeii, and the business may have been run by one of his freedmen. The characteristic features of this and the other 33 bakeries discovered throughout the city are the mills and the wood-fired oven, very similar to the one still in use in a Neapolitan pizzeria. The mills, made of volcanic rock, comprised a conical block (*meta*) cemented onto a base and a hollow biconical cylinder (*catillus*) supported by a wooden frame. A pole was inserted into the side and the cylinder was made to rotate by a donkey, the grain being poured in from the top and ground between the two blocks of stone. Bread became a common foodstuff from the 2nd century BC onwards.

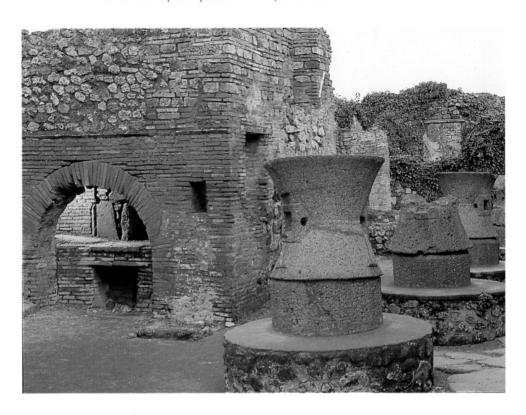

This alleyway, known as "Brothel Alley" from its most characteristic building, is one of only two streets that do not conform to the rectangular grid pattern imposed during the urban expansion in the 4th and 3rd centuries BC, and which also basically characterised the first settlement on the site (*Altstadt*).

The alleyway actually runs round the edge of the *Altstadt*, which was itself irregular, probably on account of a dip in the ground.

The other crooked street, Vicolo Storto, may mark the course of an ancient road that led out of the city through the Porta Vesuvio (see p.16).

VII, 12, 18

The largest and best organised of the 25 or so places of prostitution (*lupa* being the Latin for prostitute) known in Pompeii. On the ground floor there are five rooms opening off a corridor with a small latrine at the far end. There are five more rooms upstairs, reached through a separate entrance and along a landing. The stone beds were of course provided with a mattress. This is the only building known to us which existed specifically for this trade. All the other places of prostitution were either single rooms opening off the street or rooms on the upper floor of an eating house (see A14).

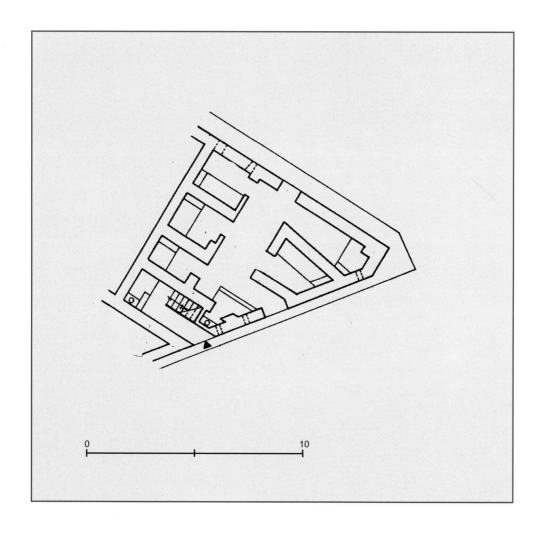

0 10

Erotic paintings

This is one of the erotic scenes in the simple, direct idiom of popular art which adorned the brothel. There is no reason to think, in spite of repeated conjecture, that each scene illustrates the "speciality" practised in that room. We know of Greek manuals of erotic positions on which the decorators probably based their work, and the intent may have been simply to "inspire" patrons. The prostitutes were slave girls, usually from Greece or the East, as we can surmise from the names in the graffiti connected with the trade. The cost seems to have been fairly low, ranging from two to eight *assi* (one *as* being the price of a glass of table wine). The income, all of which went to the owner of the establishment (*lenone*), was taxed during the reign of Caligula.

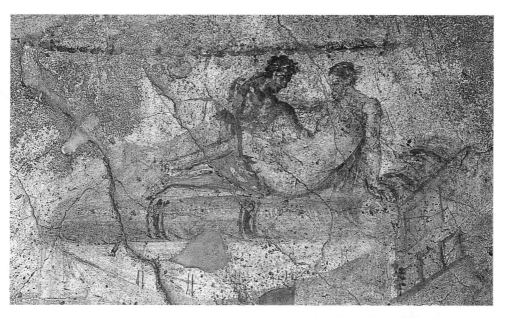

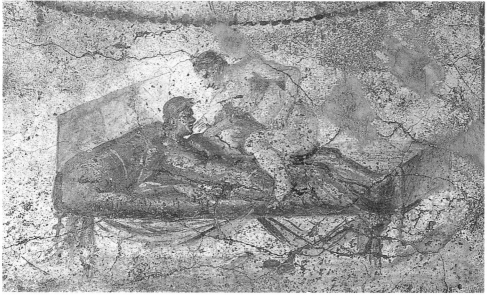

This triangular open space was included in the fundamentally coherent urban scheme applied to the whole district of the theatres during the 2nd century BC. It is situated on the southern extremity of the lava mass on which Pompeii developed, overlooking the sea and the Sarno river. A majestic gateway with Ionic columns opens onto the forum, which is surrounded on three sides by a Doric colonnade, the southern side being left open for its splendid panorama. The whole cultural and religious complex, comprising the forum, theatres and three temples (Doric, of Isis and of Zeus Meilichios), is more Hellenistic in appearance than Italic, and it may be no coincidence that it is situated on the edge of what was in origin an Italic city.

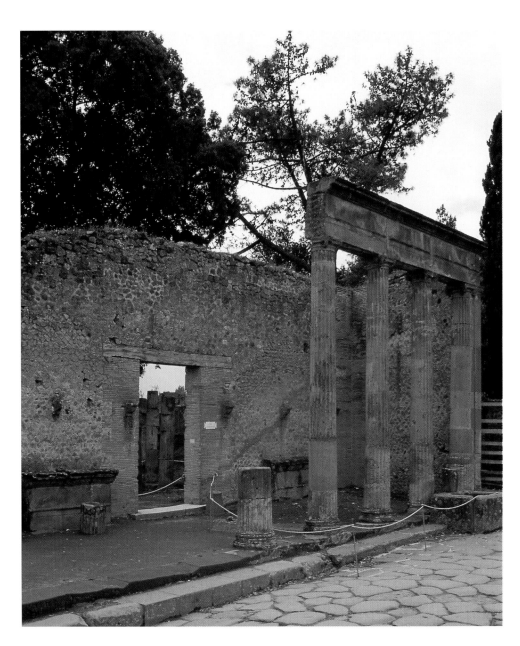

Tholos

Just to the south of the Doric Temple there is a delightful circular edifice with a Doric colonnade (*tholos*) made of tufa that would presumably have had a conical roof. At the centre of the colonnade is a well excavated in the lava which reached down to the water table. The inscription in Oscan on the architrave of the well records its construction through the good offices of the Samnite magistrate Numerius Trebius.

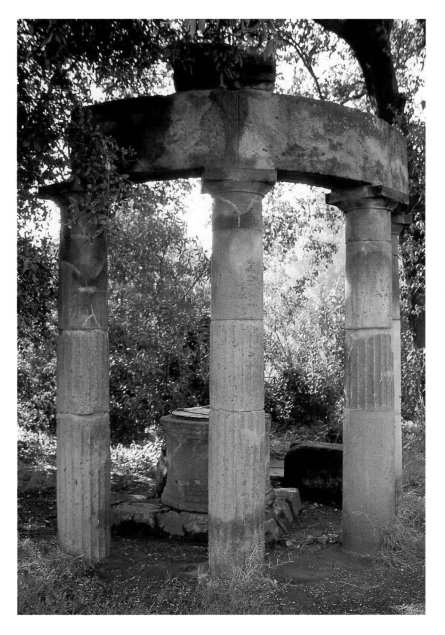

Built in the first half of the 6th century BC, it was repeatedly rebuilt, as we can see from the various architectonic elements that have come to light, while in the Roman age it may already have fallen into disuse. The temple is basically in the Doric style, including the capitals which have survived from the archaic period, with some Etruscan and Italic elements. The cella must have been deep and surrounded by a colonnade with seven columns across the front and eleven down the sides. There are steps all round the base, varying in number on each side to compensate for the differences in level of the sloping ground. It was probably dedicated both to the goddess Athena (Minerva) and to Hercules, whose cult was widespread among the Italic peoples.

Built in the 2nd century BC, it made use of the natural slope of the lava mass on which the city was situated for the disposition of the terraces (*cavea*). These, in the shape of a horseshoe, were originally separated off from the stage (as in Hellenistic theatres) and comprised three tiers. The lowest (*ima cavea*) level was faced in marble and reserved for the decurions (see C3) and the leading citizens. The corridor running round beneath the *summa cavea* and the boxes over the corridors leading into the theatre (*parodoi*, originally open to the sky) were added in the reign of Augustus. With these additions the theatre could hold as many as 5,000 spectators.

The proscenium and stage building, in *opus lateritium*, date from the restoration work undertaken following the earthquake of 62 AD and still incomplete at the time of the eruption. The stage building would have been faced with marble and adorned with sculptures. The performances are likely to have included plays by Plautus and Terence and certainly the Atellanae, popular farces in Oscan which resembled the Commedia dell'Arte, as well as the ubiquitous "mimes and pantomimes" complete with music and dancing.

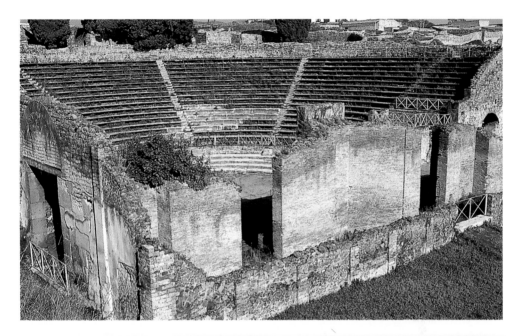

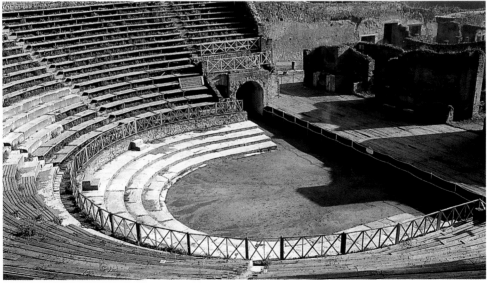

As was the rule for Hellenistic theatres, duly recorded by Vitruvius in his *De Architectura*, the theatre in Pompeii had a spacious quadriporticus, a sort of foyer where spectators could stroll between performances or take shelter in case of rain. However, this example with its Doric colonnade was not put up until the beginning of the 1st century BC, perhaps at the same time as the building of the Small Theatre. It gave onto Via Stabiana and served as a public square and meeting place for all the citizens. After 62 AD additional structures were built, on two storeys, along the external walls. Many of these cubicles were found to contain gladiatorial equipment, suggesting that in the last years of the city's existence this building was used as a barracks for gladiators.

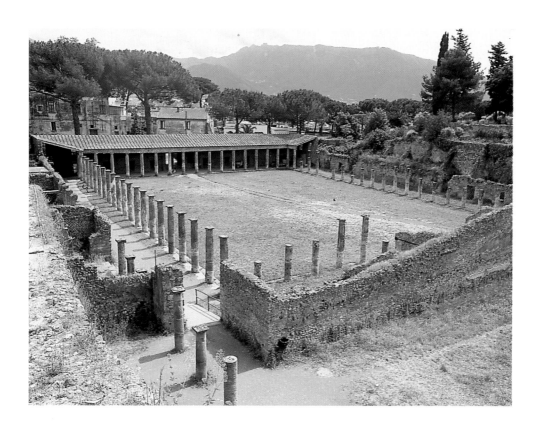

Built soon after the installation of Sulla's colony, we know it was a covered theatre from inscriptions found *in situ*. The roof must have rested on the walls that run round the *cavea*. As in the large theatre, the ima *cavea* can be seen, with its broader and shallower terracing to accommodate the seats (*bisel-lia*) of the decurions. The balustrade separating the *ima* from the *media cavea* is decorated with the winged feet of griffins, and kneeling telamons look down from the parapets on either side of the cavea. The roofing must have ensured very good acoustics, and concerts and poetry recitals were held here.

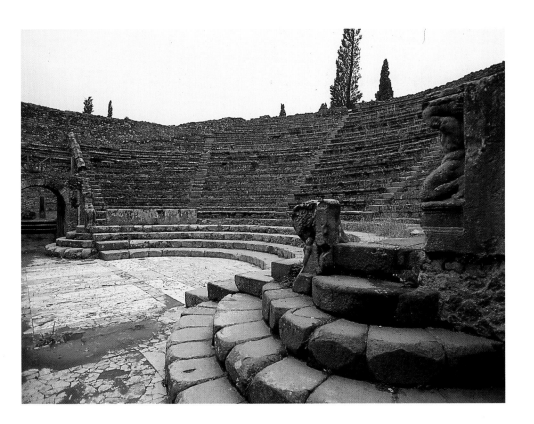

Erected towards the end of the 2nd century BC and badly damaged in the earthquake of 62 AD, it was one of the first monuments to be restored, showing how popular the cult of Isis had become (see C9, p. 146). The restoration was undertaken by the freedman N. Popidius Ampliatus, who as we learn from an epigraph ascribed the merit to his six-year-old son Popidius Celsinus in order to launch him on a political career. In fact, in spite of his tender years, Celsinus was immediately admitted into the college of the decurions. Between the arches of the portico were rooms used for ceremonies and for the temple upkeep. Inside there are altars, an enclosure with a basin for the water used in purification rites, and the temple itself with its cella on a raised dais adorned with columns and a flight of steps leading up from the front.

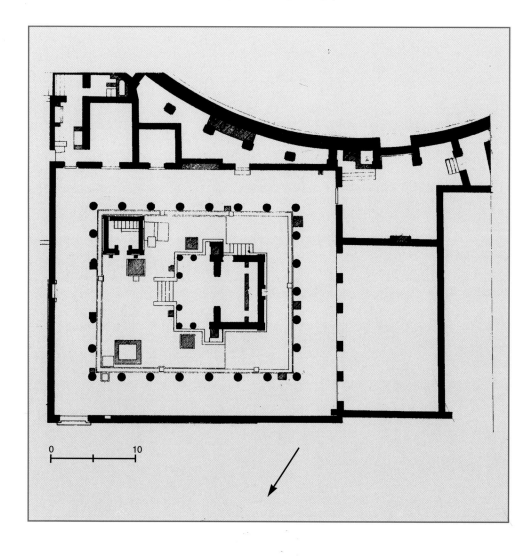

0 10

Interior

This small temple is remarkable for its inventive architecture, enhanced by the rich stucco decoration (part of which has survived) and the frescoes in the "fourth style" (which were removed from the walls during excavations in the years 1764-1766 and can be seen in the Naples Museum). The alcoves in the side walls of the large cella, like the altars standing in front of them, would have been dedicated to Anubis and Harpocrates. In the alcove in the end wall there was a statue of Bacchus. The discovery of the temple of Isis made a great impression throughout Europe and certainly contributed to the fashion for all things Egyptian in the late 18th century.

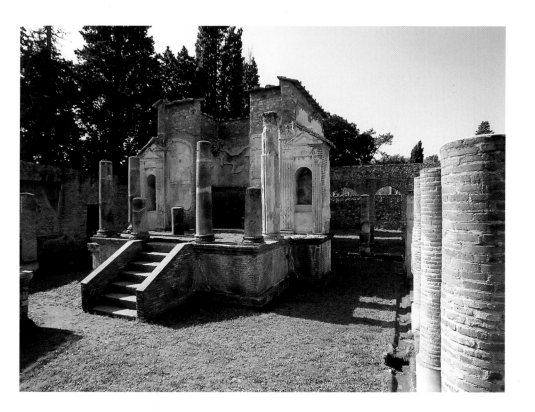

Paintings

The high quality wall paintings (now in the Naples Museum) include still lifes, priests of Isis, naval battles, Egyptian-style landscapes, a vine adorned with pygmies and exotic beasts and pictures showing scenes from Greek and Egyptian mythology. The cult of Isis and Serapis, renewed in the 3rd century BC by Ptolemy I in a fusion of Greek and Egyptian elements, spread through Italy a century later (the shrine of Serapis in Pozzuoli is known to have been in existence in 105 BC). Its popularity, especially among the lower classes, was due to its promise of a better life to come.

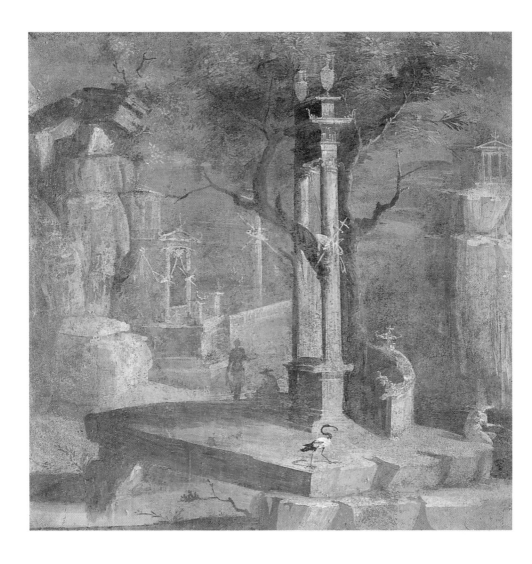

I, 10, 4

Covering an area of more than 1,800 square metres, it is one of the largest houses in Pompeii and must have belonged to one of the most affluent families, quite possibly the Poppaei, the family of Nero's wife Poppea. Dating from the last part of the 3rd century BC, it conserved its basic layout of an "atrium house" (see A16) while undergoing numerous alterations and enlargements at the expense of neighbouring properties in the next two centuries. Here as elsewhere the focal point of the house became the garden with its peristyle, around which were the reception rooms, baths and corridors leading to the servants' quarters.

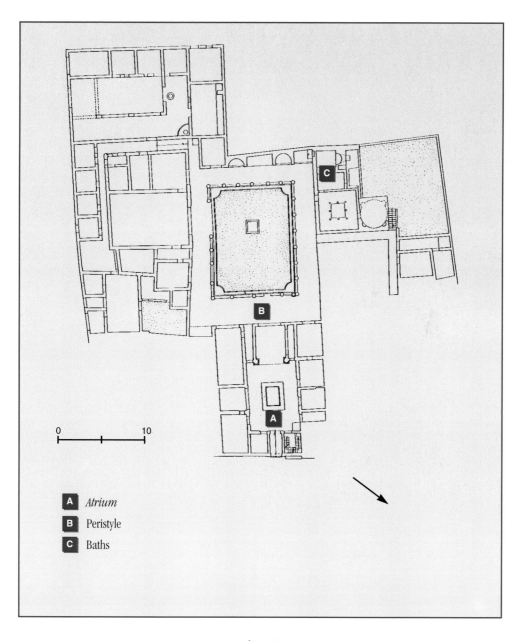

0 10

A *Atrium*

B Peristyle

C Baths

Atrium

In the atrium stands the large lararium. These shrines were the focus of domestic worship and could come in the form of a simple niche, wall paintings or, as in this case, a miniature temple in masonry. The divinities, represented by bronze miniatures or paintings, were the Lares, the guardians of the family and hearth, and the Genius, the vital essence of the head of the household. In addition there may have been gods from the Roman pantheon such as Mercury, Bacchus, Venus, Minerva and Hercules or even, as in the House of the Golden Cupids, the triad of Jupiter, Juno and Minerva. It was also not unusual to find foreign deities, especially Egyptian ones (see C9, p. 146).

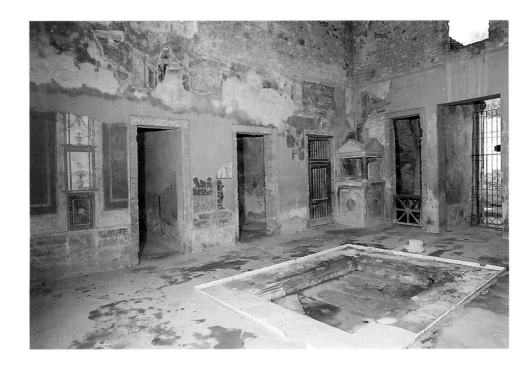

Paintings

This room, whose purpose is not certain, is decorated like all the atrium area in the "fourth style". In particular it contains three scenes from the final stages of the Trojan Wars. From left to right we see Laocoon strangled by snakes together with his children for seeking to prevent the admission of the wooden horse into the city; Cassandra opposing the entry of the wooden horse concealing Greek warriors; and, following the fall of Troy, Menelaus seizing his unfaithful wife Helen by the hair while Ulysses wrests Cassandra from the simulacrum of Minerva.

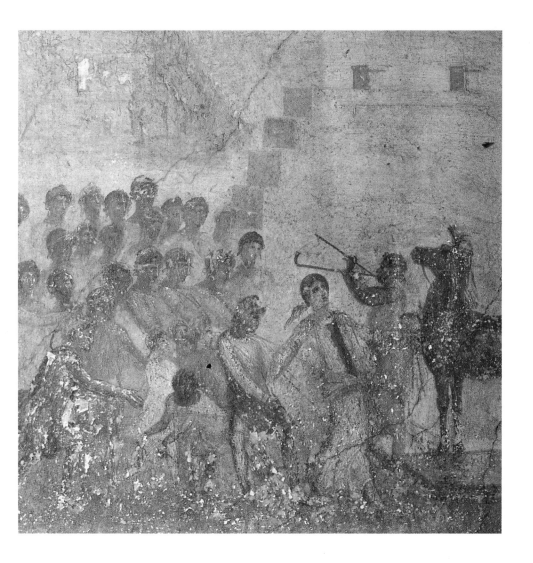

Mosaic

The floor of this room contains a mosaic *emblema* in the centre showing a Nile landscape in which a boat is being guided by pygmies with villas and trees lining the riverbanks. Such polychrome images, often produced in the workshop and then set into the flooring, are made up of tiny tesserae mounted on either a tile or slate. The minute size of the tesserae allows for a richness of detail and nuances of colour that give the finished product the effect of a painting. They are typical of the Hellenistic age and thus of the first and second decorative styles. They tended to disappear during the third and fourth styles (see C1 p. 123, C8 p. 139) when a painting became an essential feature of wall decoration.

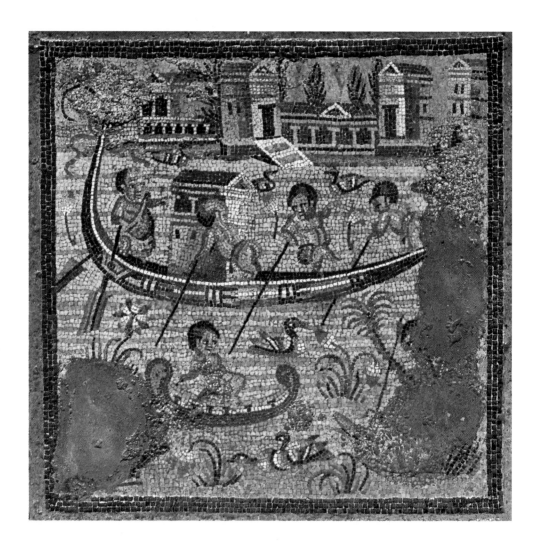

Peristyle

On the right wall of the rectangular recess at the back of the peristyle there is a portrait of the Greek dramatist Menander, giving the house its name. The paintings on the other walls, in very poor condition, must have shown, on the left, the tragedian Euripides, and in the centre two tables displaying the masks used in performances of comedy and tragedy. At the far right of the wall there is a subsidiary domestic shrine where, as was customary, the *imagines maiorum* were venerated. These were busts made in wood or wax of the family's ancestors, from which it proved possible to take plastercasts.

Baths

The baths, in common with other parts of the house, were being rebuilt when the eruption struck. They comprised a tetrastyle courtyard, a changing room and a hot room with a delightful mosaic floor showing marine creatures and negroids. The mosaic on the threshold represents a servant holding out jars of bath oils.

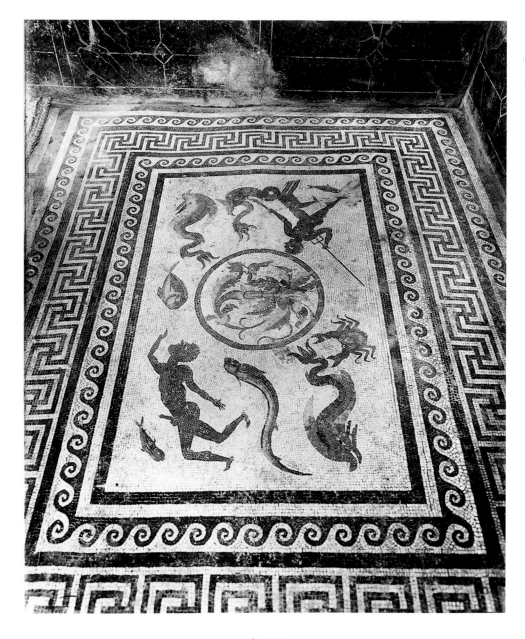

I, 6, 15

The attribution to L. Ceius Secundus is based on an electoral slogan painted on the housefront, which still conserves its "first style" plasterwork (see C1, p. 119).

The layout of the house is quite simple: the entrance gives onto the atrium, with on either side a bedroom and the kitchen, next to which stairs lead up to the second floor running the length of the façade. Beyond the atrium are the dining room and the tablinum, and between them a passage leads to the back of the house, mainly occupied by the garden. A flight of stairs in *opus craticium* (mortar in a wooden frame) was to lead to more rooms on a second floor above the tablinum, still under construction.

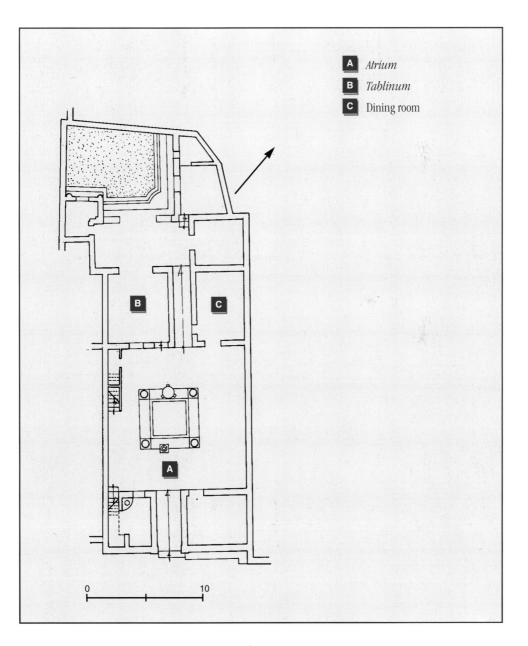

A　*Atrium*

B　*Tablinum*

C　Dining room

0 10

Atrium

The atrium and adjoining rooms are decorated in late "third style" (see C1 p. 123, C8, p. 139) with floors in *lavapesta* (a compound of crushed volcanic stone) and *cocciopesto* (mortar and brick fragments) decorated with tesserae, *opus signinum*. The floor in the tablinum is particularly elaborate, in *cocciopesto* embellished with geometric motifs in white tesserae interspersed with tiles of coloured marble. In the centre there is an *emblema* in *opus sectile* (the tarsia of coloured marble that became very fashionable from the middle of the 1st century AD) framed by a mosaic of a vine and a plait, common features of the third and fourth "styles" (early Imperial age).

Garden

The small garden is made to seem larger by the grandiose hunting scene complete with wild beasts on the back wall, set off by the idyllic Egyptian-style landscapes on the side walls. Such scenes and landscapes, very common in the decorative schemes from the last years of Pompeii, conjured up spacious patrician villas and exotic foreign climes in a sort of escapism from the confined and more mundane reality of day to day life.

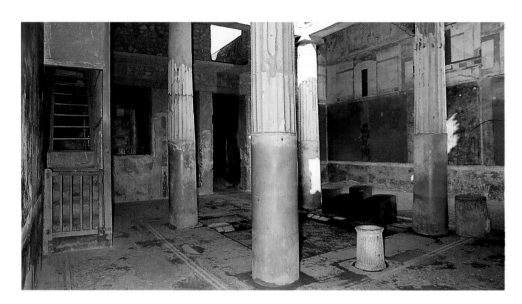

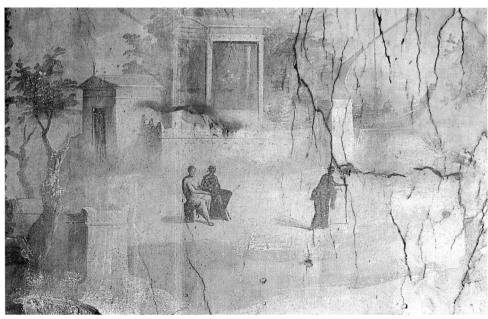

Da Via dell'Abbondanza
a Porta Nocera

From
Via dell'Abbondanza
to Porta Nocera

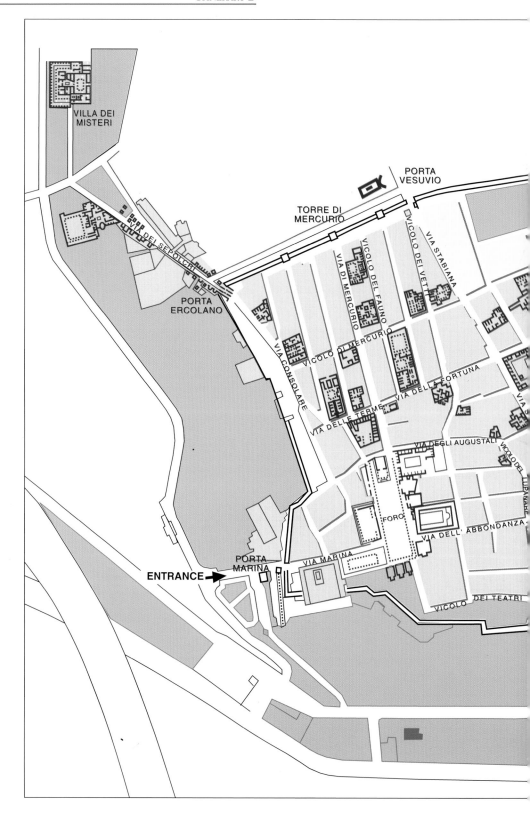

VILLA DEI
MISTERI

PORTA
VESUVIO

TORRE DI
MERCURIO

VIA DEI SEPOLCRI

PORTA
ERCOLANO

VICOLO DEL FAUNO

VICOLO DEI VETTI

VIA STABIANA

VIA DI MERCURIO

VIA CONSOLARE

VICOLO DI MERCURIO

VIA DELLA FORTUNA

VIA S

VIA DELLE TERME

VIA DEGLI AUGUSTALI

VICOLO DEL LUPANARE

FORO

VIA DELL'ABBONDANZA

ENTRANCE ▶

PORTA
MARINA

VIA MARINA

VICOLO DEI TEATRI

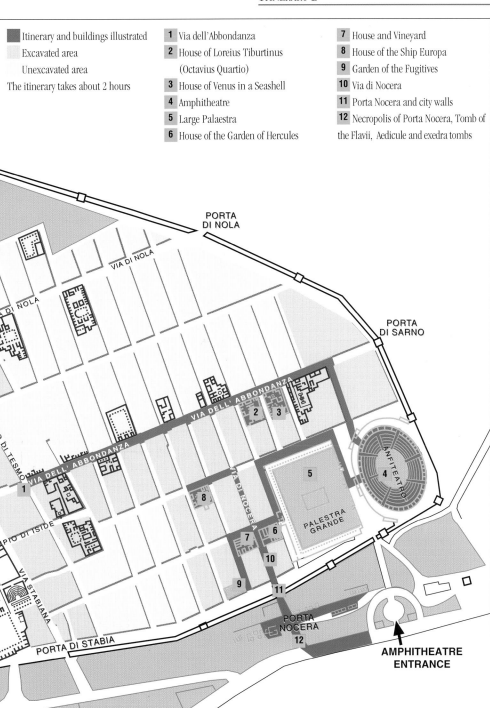

Itinerary and buildings illustrated
Excavated area
Unexcavated area
The itinerary takes about 2 hours

1 Via dell'Abbondanza
2 House of Loreius Tiburtinus (Octavius Quartio)
3 House of Venus in a Seashell
4 Amphitheatre
5 Large Palaestra
6 House of the Garden of Hercules

7 House and Vineyard
8 House of the Ship Europa
9 Garden of the Fugitives
10 Via di Nocera
11 Porta Nocera and city walls
12 Necropolis of Porta Nocera, Tomb of the Flavii, Aedicule and exedra tombs

One of the main arteries through Pompei, running roughly east-west. It starts at the Forum where the public fountain with a sculpture depicting the Concordia Augusta bearing the horn of plenty gives the street its modern name. It goes down to the so-called Porta di Sarno, linking the "old city" with the quarters that grew up during the 3rd century BC (see p. 20, A19, B10). The layout of the city was rationalised by Giuseppe Fiorelli on the basis of the street plan, identifying nine Regiones like the quarters of Ancient Rome, each divided into Insulae or blocks. It was thus possible to give each building its own "address", comprising the Regio, Insula and number in the block.

II, 2, 2

This name is in fact mistaken, for from a signet ring found in the room to the right of the entrance we know that the owner was Octavius Quartio. The entrance area retains the original layout, from the 2nd century BC, of an "atrium house" belonging to a well-to-do citizen (A16, p. 52). Originally the atrium was the central feature of a house, with all the other rooms opening off it, including the bedrooms, the dining room and the tablinum, where the householder received his clients. The area beyond the atrium was restructured following the earthquake of 62 AD, when the tablinum was eliminated and the garden considerably enlarged, in imitation of the country villas set in parkland amidst streams and lakes.

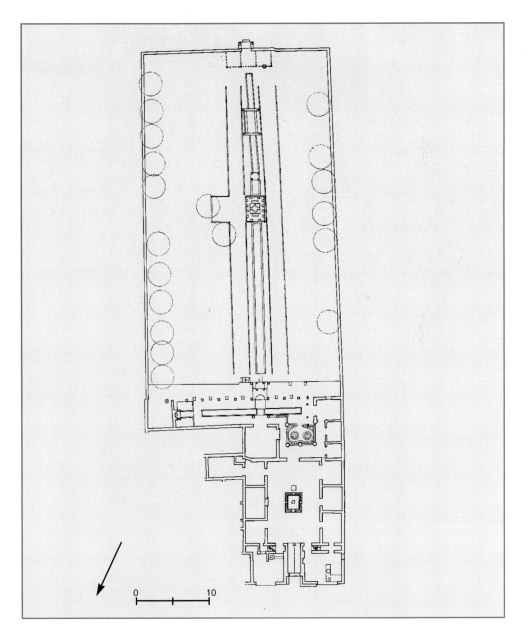

0 10

Mythological Scene
The painting on the external wall of a room believed to have been used for the cult of Isis-Diana represents the myth of Diana and Acteon. The goddess of hunting, seen in the nude by the young hunter while she was bathing, punished the hapless intruder by turning him into a stag and setting her hounds onto him.

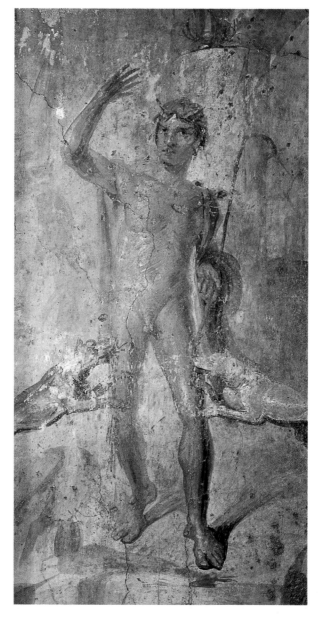

Cult scene

The room is decorated in the "fourth style" on a white background and identified with the cult of Isis, on account of this portrait of a priest of the Egyptian goddess.

Bald-headed and dressed in a linen garment, he holds a sistrum in his right hand, the characteristic musical instrument used in the Isiac rites. Other objects found in the house also refer to the goddess, whose cult gained considerable popularity from the 2nd century BC onwards not only in Pompeii but throughout Campania and Italy in general.

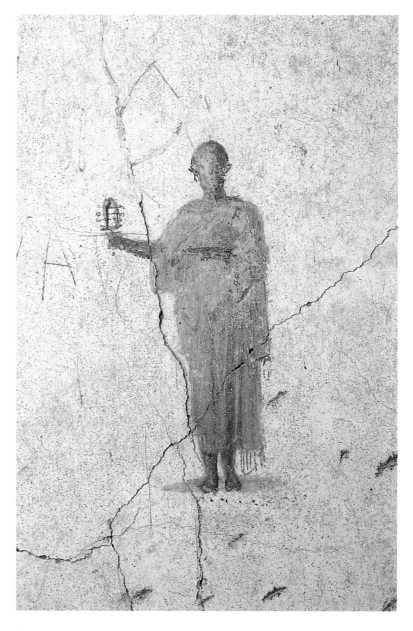

Upper garden

The watercourse (*euripus*) with its trellised portico was embellished with numerous small statues on either side, some of which, like the sphinx and the head of Jupiter-Serapis, evoked Egypt, the home of Isis. Half way along, overlooking the lower garden, stands a tempietto with fountains playing round it.

At one end of the upper watercourse is a double couch in masonry for al fresco meals, with behind it a niche inlaid with pumice stone to look like a grotto. This sort of nymphaeum, the watercourse, the couches and the elaborate garden are all elements borrowed from the large country villas, scaled down to fit the confines of a town house. On each side of the grot-

to there are illustrations of well-known myths. On the right is Narcissus, enamoured of his own reflection in a pond. On the left the ill-starred Pyramus and Thisbe, the former killing himself in the belief that his beloved has been devoured by a lion, provoking her to suicide when she comes across his lifeless body.

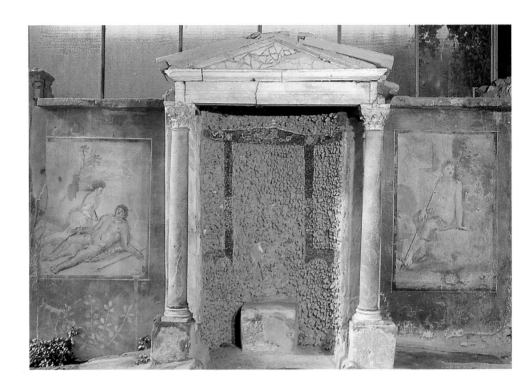

Lower garden

The large garden is traversed by a longer watercourse in three sections, which some believe to have been fish ponds. It issues from another nymphaeum below the tetrastyle tempietto, adorned with a mask of the god Oceanus and a miniature statue of Eros (no longer *in situ*). Flanking this grotto are two more representations of Diana and Acteon. The watercourse was shaded by a trellised portico which has recently been repristinated.

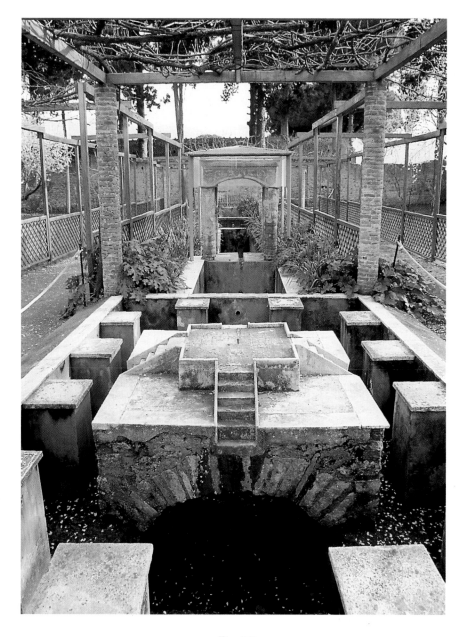

II, 3, 3

This house too seems to have been adapted from an "atrium house" in which the tablinum was eliminated to give pride of place to the peristyle, as was the fashion in the Imperial age. The dining room was spacious and conveniently opened onto both the atrium and the peristyle, affording views of the garden. The area of the atrium was damaged by one of the numerous bombs that fell on Pompeii in 1943.

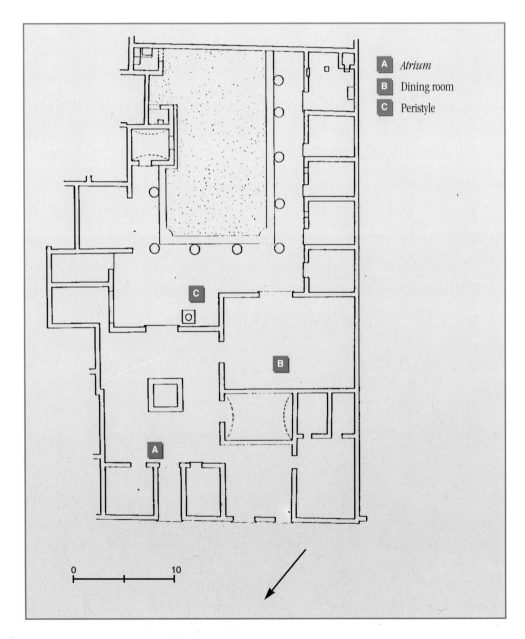

A Atrium

B Dining room

C Peristyle

0 10

Peristyle

The importance of the peristyle puts this into the category of the "peristyle house". Not only are there fine views through its columns into the garden but round the peristyle, which is visible from the entrance, are grouped most of the rooms, making this the hub and focal point of the whole building.

Garden

The rear wall of the garden with its large, striking wall painting is the main feature of this house.

It shows a garden behind a low fence with decorative elements that have been found as actual objects in other houses (viz. Houses of the Vettii and the Golden Cupids).

In the right-hand panel we see a basin at which birds are drinking, and on the right a statue of Mars, while in the centre is the scene of Venus reclining in a seashell accompanied by two cupids towards the city of which she was the protectress (see p. 22, C4 p. 128).

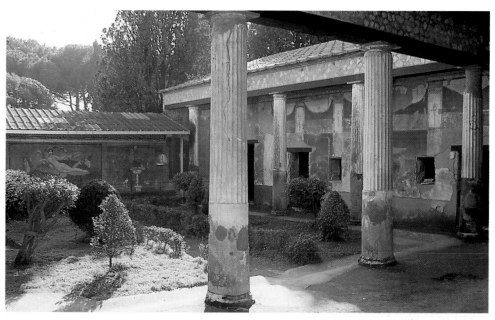

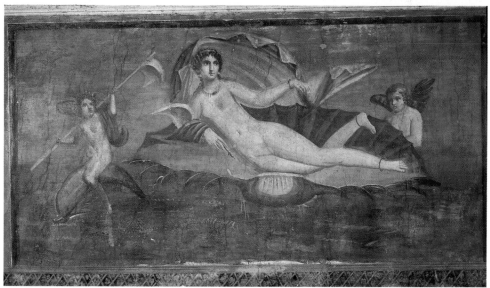

This is the oldest amphitheatre known to us anywhere, dating from 70 BC. An inscription records that it was erected by the duumvirs Quinctius Valgus and Marcus Porcius at their expense. It was customary for public figures to spend large amounts on public works. It was built against the southeastern corner of the city walls, which buttressed the shell-like structure of the terraces (*cavea*). The terraces were divided into three sectors: *ima cavea* (the front row around the arena) for the magistrates and leading citizens, *media cavea*, further up, and *summa cavea*, at the top, holding 20,00 spectators in all. The tall parapet surrounding the arena was decorated with paintings of gladiatorial combats, hunting scenes, victory celebrations and so on. Gladiatorial shows, which derived from ritual combats in honour of the dead, enjoyed great popularity. During one show in 59 AD the supporters of the rival "teams" became involved in a violent brawl causing numerous casualties. The sporting partisanship was in fact only a pretext, for the citizens of Pompeii had a score to settle with the people from nearby Nuceria which, having recently become a colony, had taken over part of the territory of Pompeii. After the disorders the emperor Nero "disqualified" the amphitheatre for ten years, but the ban was revoked following the earthquake in 62 AD.

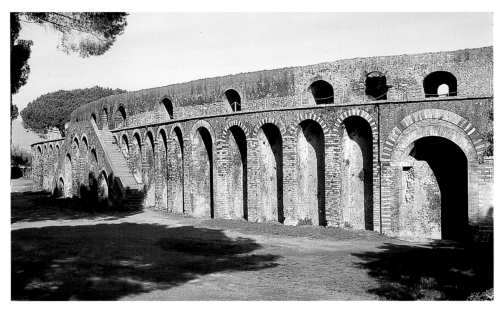

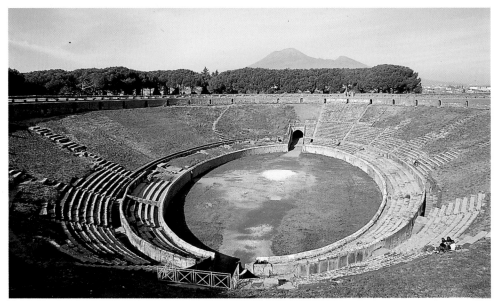

This large open space, surrounded on three sides by a portico, has a swimming pool in the middle and was once shaded by large plane trees, the roots of which have been reproduced in plaster casts. At the centre of the western portico stands a room which seems to have been devoted to the Imperial cult, with the base for a statue still *in situ*. The gates on the eastern side were rebuilt in *opus lateritium* (compound of mortar and stones faced with brickwork) following the earthquake of 62AD, while at the time of the eruption the northern wall was still awaiting repairs and lay as it had fallen. It was rebuilt during the recent restoration work so that the wall painting in the "third style" could be restored to its original position. The southern portico leads to the latrine, joined by a channel to the swimming pool for periodical flushing. The building was put up during the reign of Augustus as an exercise ground, possibly for military training as well as gymnastics, for use by the youth organisations that the Imperial ethos promoted.

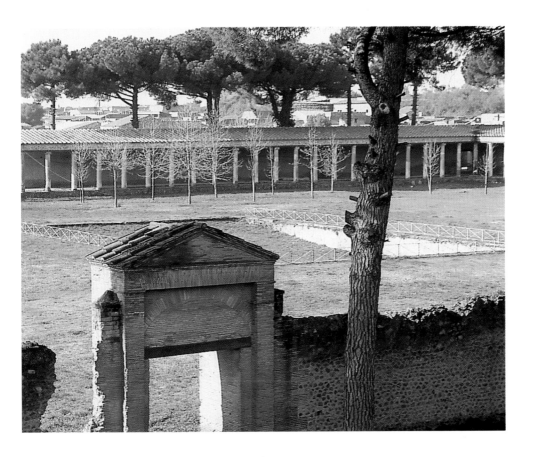

II, 8, 6

In its original form, before the addition of the large garden, it belonged to the category of "terrace houses" which was very common in Regio I and II. Built during the 3rd century BC, such houses have a courtyard which served as a hall, probably unroofed, across the breadth of the house. This was preceded by an entrance with bedrooms (*cubicula*) on either side and an upper storey. A corridor led from the entrance towards the garden plot (*hortus*) at the far end of the house. The roof over the courtyard and the upper storey may have been later additions

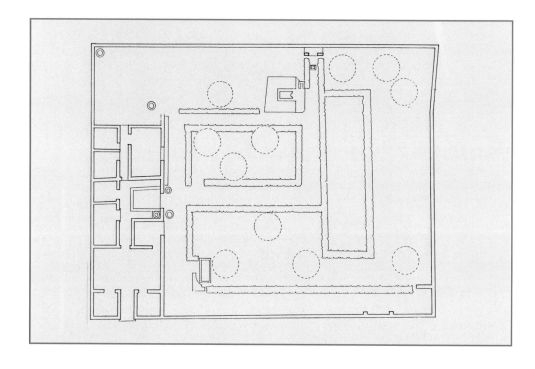

Garden

The large garden was created in the middle of the 1st century BC by knocking down five adjacent "terrace houses".
The layout and type of plants it contained have been restored to their original state on the basis of paleobotanical studies. Many of the plants were suitable for manufacturing perfume, and it seems likely that this was the householder's trade. At the centre of the eastern wall, next to the stonework couches of a triclinium for al fresco meals, are an altar and aedicule for the cult of Hercules. The marble statue of the god found in the garden gave the house its name.

I, 20, 5

This is a simple structure, one of the numerous houses of the poorer classes which had to fit into whatever space was available and thus do not conform to a typological classification. The two-storey building has a series of interconnecting rooms, with the living quarters on the top floor, and the ground floor being the workplace. As in many Insulae in this part of Pompeii, a lot of ground was under cultivation, in this case with fruit trees and above all grapevines. Wine production was one of the main components of the city's economy.

I, 15, 3

This house does not have the characteristic features of an "atrium house". Instead, all the rooms open off the peristyle, the true focus of the building, which one enters immediately after the entrance hall. It in turn gives onto a large plot of land, occupying the rest of the Insula, which paleobotanical research has shown to have been a vegetable garden and vineyard.

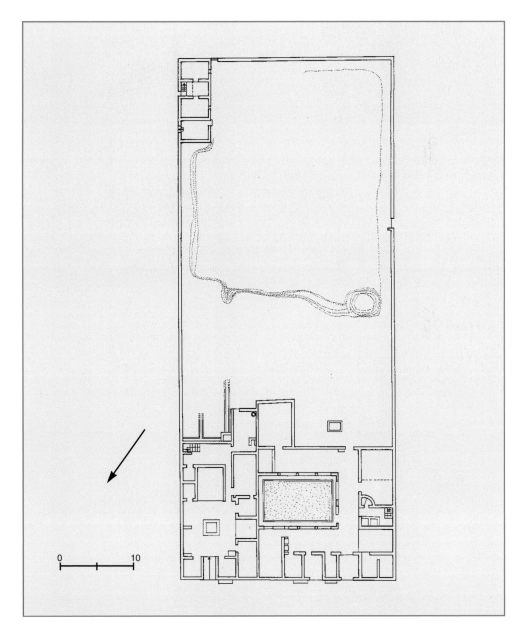

0 10

Peristyle

The house was excavated in the 1950s. Recent research, carried out as part of extensive restoration work done to this part of Pompeii, has made it possible to rebuild the upper part and roof of the house.

This was done exactly as it would have been in ancient times, using the same techniques and materials, with wooden roof- and cross-beams overlaid by tiles.

Graffito

Many houses in Pompeii for which it has not been possible to identify the owner have been given a name on the basis of finds from the site, such as a significant object, fresco or mosaic, or of events like an anniversary linked with the year of excavation or the visit of a famous person. This house takes its name from a graffito visible on the northern wall of the peristyle showing a merchant ship with EUROPA inscribed on its hull, presumably referring to the Greek heroine beloved by Zeus who gave birth to Minossus, the mythical King of Crete.

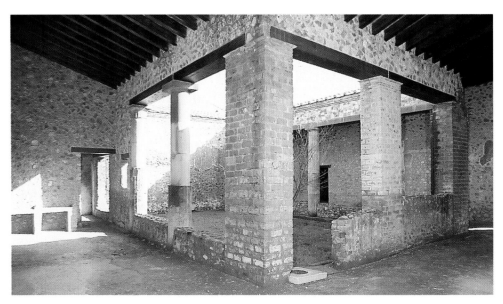

I, 21

This large garden, occupying the whole Insula, was a vineyard, and takes its name from the victims of the catastrophe that destroyed Pompeii in 79 AD found here. They were overcome as they tried to flee the inexorable eruption. The method of taking plastercasts, still in use virtually unchanged today, was introduced at Pompeii by Giuseppe Fiorelli, director of the excavations between 1860 and 1875. It involves pouring liquid plaster (which solidifies in a day or two) into the cavity left in the compacted ash by the body of the victim. On account of its composition and extreme temperatures, volcanic ash rapidly becomes very compact, preserving, like a mould, the cavity that forms as the body decays. In this vineyard there was also a triclinium with stonework couches for openair repasts.

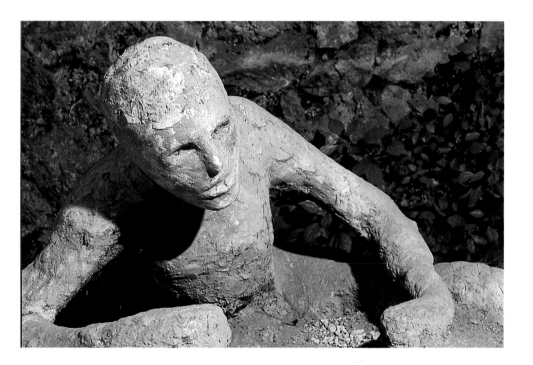

This street, paved like all the streets in Pompeii with blocks of hard lava, runs between Regio I and Regio II (see B1). This district became built up towards the end of the 3rd century BC, when a series of similar houses were built, giving onto a small plot of open land. In the mid 1st century BC the number of dwellings was reduced, leaving more room for gardens and in particular for orchards and vineyards. It was apparently a middle class district, where the activities were primarily commerce and handicrafts.

Recent restoration has made it possible to rebuild the upper parts and roofs of the houses lining this road in their original state.

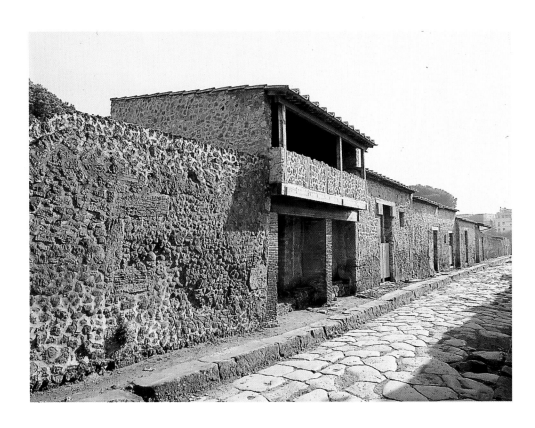

The gate and adjacent walls, made of large limestone blocks, go back to the so-called "first Samnite phase". They were built during the 4th century BC following the occupation of Pompeii by the Samnites at the end of the previous century (see p. 14, A1, C11). Recent excavations have brought to light remains of the first walls on the site, outside the gate. The road into the city is flanked by robust bastions. The unusual height of the gate is due to the fact that over time the level of the road surface has dropped.

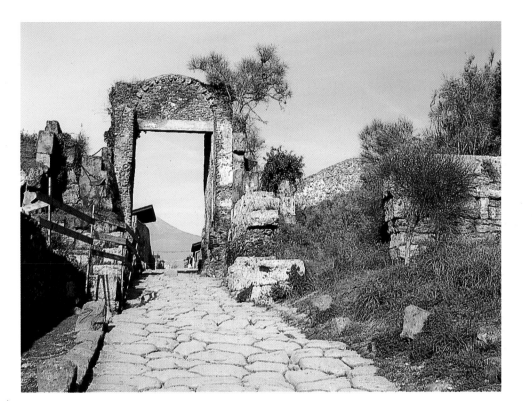

Excavated in the years 1954-56, the necropolis contains tombs of various types, ranging from the plainest, a simple brick enclosure, to the most elaborate, full-blown funerary monuments complete with architectonic and sculptural decoration. As was customary in Roman necropolises, the tombs lined a busy road (in this case the road to Nuceria) so that they would be noticed by passersby and stand in perpetual memory of the dead person and family. The tombs on this site date from between the middle of the 1st century BC and the second half of the 1st century AD.

Tomb of the Flavii

The tomb, dating from the late Republican age (50-30 BC), is unique among the funerary monuments in Pompeii. It comprises two chambers linked by a central arch; in the façade there are a series of niches, some still bearing an epigraph and the portrait of the dead person. It belonged to the freedmen of the citizen Publius Flavius, who was probably one of the soldiers settled in the new Roman colony following the conquest of the city by Sulla in 89 BC during the Social War. This type of funerary edifice is believed to have been typical of the class of freedmen.

Aedicule and exedra tombs

The large central tomb, erected during the reign of Tiberius (14-37 AD) by the priestess of Venus Eumachia for herself and her family, is the most impressive tomb known to us in Pompeii. It comprises a terrace with an exedra, inside which is the funerary chamber and a balustrade behind it. The upper part, which had been stripped of its decoration, must have contained a series of niches with statues, separated by semi-columns, crowned by a frieze in relief showing a battle scene of Amazons. On the terrace a series of stylised human busts indicate the burial places. This monument was inserted between two earlier tombs so as to enhance its scenographic effect. They date from the late Republican age and are of the "aedicule" type, comprising a raised dais bearing a cella with the statue of the dead person.

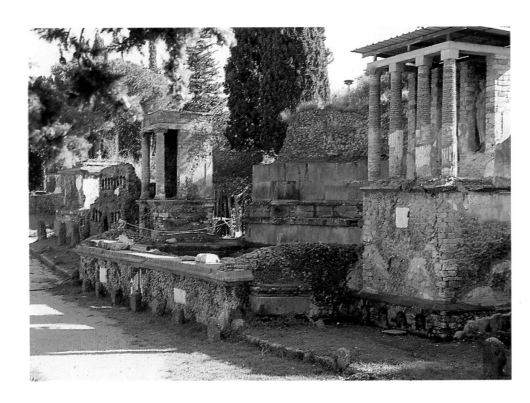

Dalla Casa di Giulio Polibio a Villa dei Misteri

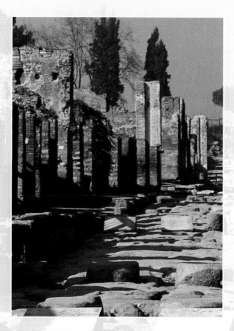

From the House of Julius Polibius to the Villa of the Mysteries

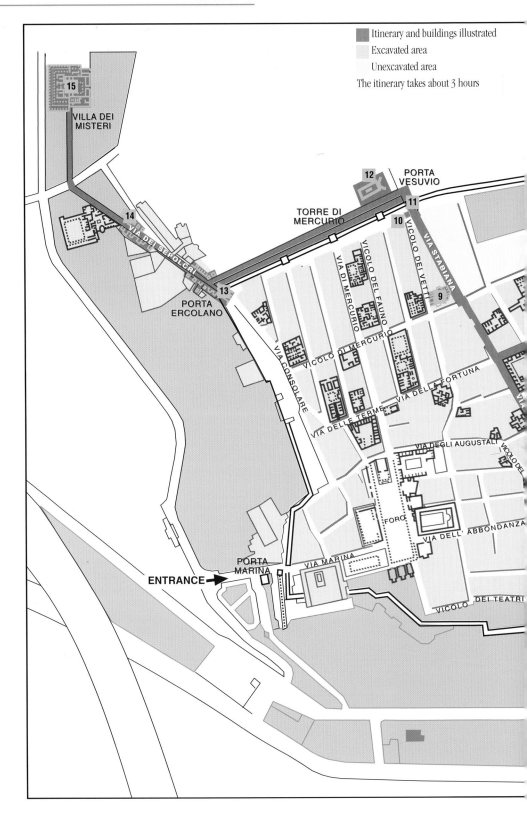

Itinerary and buildings illustrated
Excavated area
Unexcavated area
The itinerary takes about 3 hours

15 VILLA DEI MISTERI

12 PORTA VESUVIO

14 VIA DEI SEPOLCRI

TORRE DI MERCURIO

11

10

VIA STABIANA

VICOLO DEL FAUNO

VIA DI MERCURIO

VICOLO DEI VETTI

9

13 PORTA ERCOLANO

VIA CONSOLARE

VICOLO DI MERCURIO

VIA DELLA FORTUNA

VIA DELLE TERME

VIA DEGLI AUGUSTALI

VICOLO DEL

FORO

VIA DELL' ABBONDANZA

PORTA MARINA

ENTRANCE➤

VIA MARINA

VICOLO DEI TEATRI

1 House of Julius Polibius
2 Thermopolium of Vetutius Placidus
3 Electoral slogans
4 Workshop of Verecundus
5 Fullery of Stephanus
6 Stabian Baths
7 Via Stabiana

8 House of Marcus Lucretius Fronto
9 House of the Golden Cupids
10 *Castellum aquae*
11 Porta Vesuvio
12 Necropolis of Porta Vesuvio,
 Tombs of Tertulla and Septumia,
 Tomb of Vestorius Priscus

13 Porta Ercolano
14 Necropolis of Porta Ercolano,
 Tombs of Mamia and the Istacidii,
 Calventius and Naevoleia Tyche
15 Villa of the Mysteries

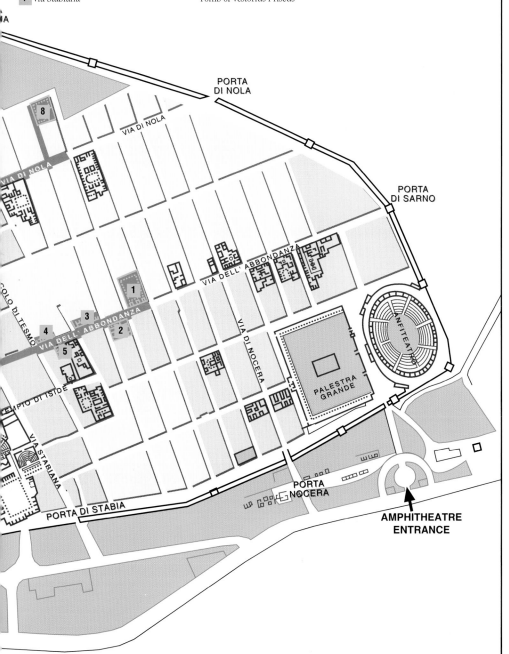

IX, 13, 1-3

The owner of this large house was the builder and candidate to the duumvirate (see C3) Caius Julius Polibius. The severe façade in the Samnite style has two entrances, one into the servants' quarters and the other, at number 3, into the residential area. Although this is still an "atrium house", it is atypical in that neither of these entrances opens onto the atrium proper. Instead, the visitor finds himself in large rooms with no opening in the ceiling, described as *atrii testudinati* (covered) or simply as vestibules.

The traditional atrium, with its inward-sloping roof, *compluvium*, channeling rainwater into the central pool, is situated beyond the vestibule in the residential area. From it on the left there is access to the kitchen and servants' quarters, and at the far end stands the peristyle.

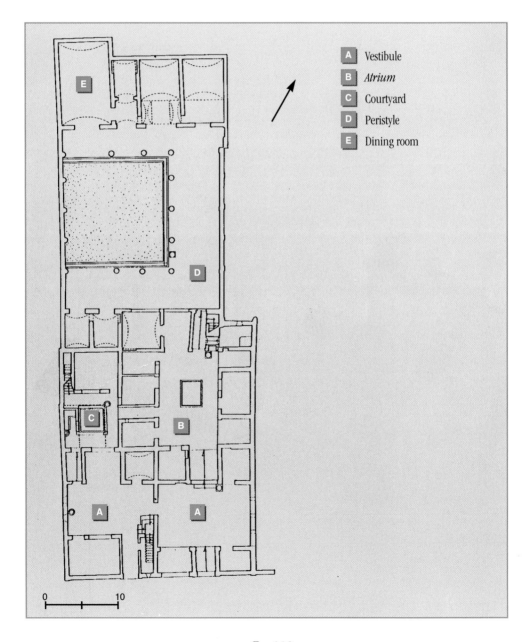

A Vestibule
B *Atrium*
C Courtyard
D Peristyle
E Dining room

0 10

Vestibule

The so-called vestibule conserves some of its decoration in the "first style". The wall paintings on plaster were first studied in Pompeii and periodised in four "styles" which are sometimes known as Pompeian although in fact they hold good throughout the Roman world (see p. 123, C15). The "first style" is to be found also in Greece from Hellenistic times until the beginning of the 1st century BC. It imitated, in stucco relief or painting, either a construction in marble slabs (hence the name "structural style") or a marble panelled wall. The *trompe l'oeil* motif of the painted door is typical of the "second style" and was added at a later date, to disguise the walling up of a previous doorway. The jars containing builder's lime show that at the moment of the eruption building work was going on in the house.

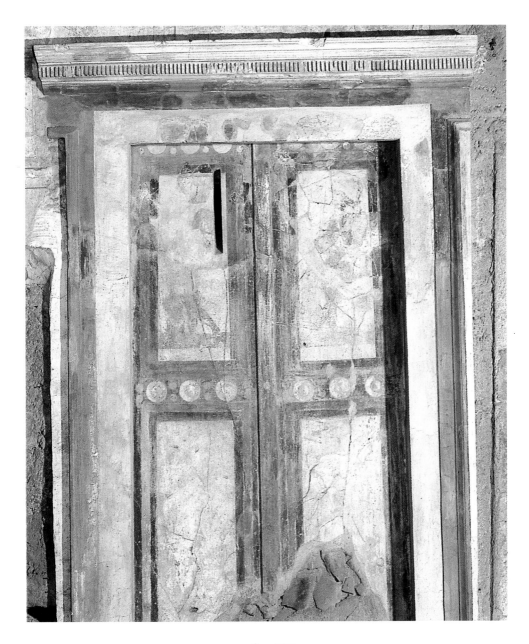

Servants' quarters

In the small service courtyard, overlooked by the upper storey rooms (possibly servants' bedrooms), stands a minuscule cooking stove. It has been possible to reassemble all the elements which belonged on top of it including the cowl. Pots and pans in everyday use, a metal tripod and a grill were found on the stonework range where the fire was tended.

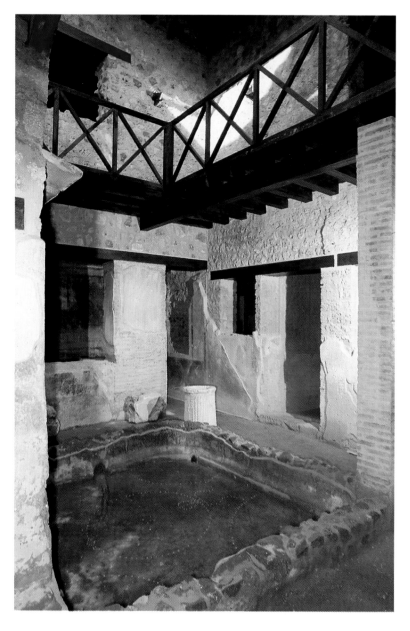

Kitchen and lararium

The large painting beside the stove is the household lararium, the shrine where the Lares were worshipped as guardians of the house and family. They are depicted at the top on each side, while along the bottom is the snake known as the agathodemon, which protected the hearth and brought fertility. It is depicted wrapping itself round the altar on which the house-holder, shown with the attributes of the Genius (his tutelary spirit), is making a sacrifice assisted by his wife. Also taking part in the ceremony are a youth bearing offerings and a flute player. Graffiti refer to Caius Julius Philippus (see C1, p. 122), a gift of precious stones made by Nero's wife Poppea to the Pompeian Venus and the visit of Nero himself to the temple of Venus. The scenes decorating lararia are the most common examples of popular art, rather rough and ready and quite separate from the evolving "styles" of the more formal wall paintings.

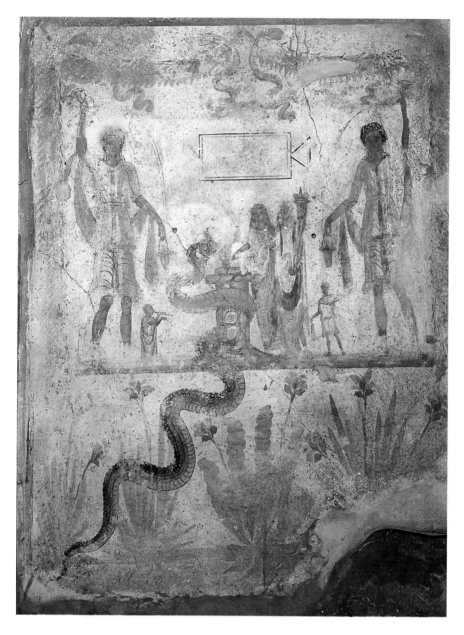

Peristyle

During excavation work some cupboards were identified in the peristyle from which it was possible to make plastercasts that reveal the original fastening in bone and bronze fittings. The cupboards may have been put out in the peristyle to make room for the restoration work indoors. In one of them a bronze signet ring was found, inscribed C. IULI PHILIPPI, indicating that a relative named Caius Julius Philippus also lived with Julius Polibius. The garden in the middle of the peristyle was planted with fruit trees, and around it there were the reception and rest rooms, including a large dining room (*triclinium*). Casts were taken of some of the doors to these rooms.

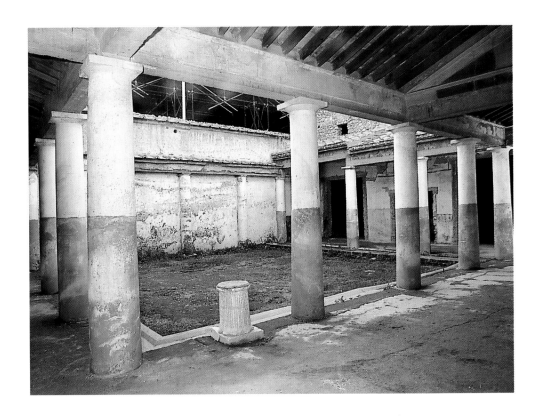

Paintings

The central room with a floor in *cocciopesto* (a compound of mortar and brick fragments) decorated with geometric motifs in white tesserae, has a fine example of late "third style" wall painting on a white background.

In the "third style" decorations, in vogue between about 25-20 BC and 45-50 AD, the wall is rigorously divided up into three parts both vertically and horizontally (dado, middle register and upper register), forming large panels of one colour, bordered by slender architectonic or vegetal designs or merely lines and with decorative motifs in the centre. The central panel is the most elaborate, containing scenes from mythology (in this case Apollo and Daphne, Hermaphrodite and Eros). The surrounding surfaces are not given relief with effects of perspective and *trompe l'oeil* as in the "second style" (see C15), the architectonic elements being deliberately schematic and devoid of realism.

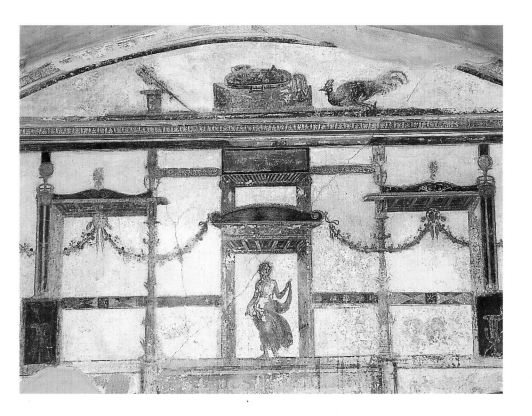

Triclinium

The painting in the large triclinium represents the myth of Dirce tied to a raging bull, killed by Anfione and Zeto in revenge for her cruelty to their mother Antiope.

Typically for scenes in the early and middle "third style", it is on a grand scale, particularly in its vertical extension, with the figures set in a spacious landscape. Another characteristic feature is that in one picture two distinct episodes are represented, as if in a cartoon: reading from right to left we see first the capture of Dirce and then her being tied to the bull. In this room, where decorating was still in progress, a heap of many high quality bronze artefacts was found, as if put on one side while the building work was going on. In particular there was bronze plate including a splendid bowl (crater) with figures in relief and a statue of Apollo bearing a tray.

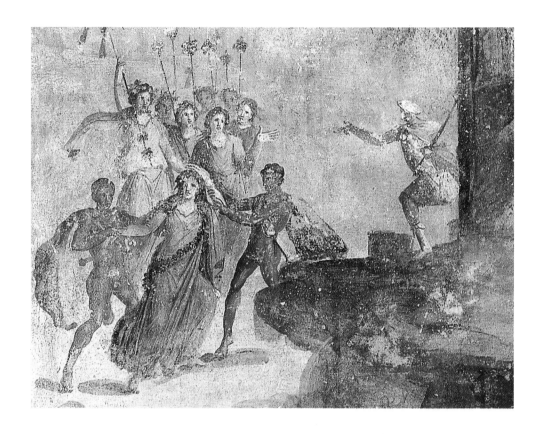

I, 8, 8

There were many such "places for hot meals" since it was common for people to eat out for their midday meal. In its simplest form it comprised a single room, even quite small, opening directly off the street, with a stonework counter into which were set the urns (*dolia*) containing the fare on offer. Sometimes customers could eat sitting down rather than at the counter, in one or more rooms at the back. The attribution derives from inscriptions painted on the front wall, which also suggest that the shopkeeper was the owner of the house next door. In addition to the customary Lares, the Genius in the act of sacrifice and the propitious snakes, the lararium painted on the back wall features Mercury, the god of commerce and profit, and Dionysus, the god of wine.

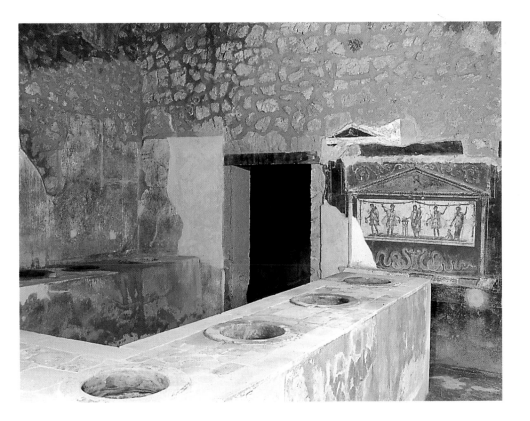

IX, 11

The phrases painted on the street walls are election propaganda, urging votes for a candidate to a certain position in the elections which were held each year in spring. A typical example is: HOLCO-NIUM PRISCUM IIVIR (um) I(ure) D(icundo) D(ignum) R(ei) P(ublicae) O(ro) V(os) F(aciatis); "I ask you to elect Holconius Priscus, a man worthy of the Republic, as Duumvir".

The city was governed by the college of decurions (with 80-100 members), presided over by two duumvirs, invested with both political and juridical authority. Rather less important were the two aediles, which represented the first stepping stone in a public career. All citizens who were freeborn and of irreproachable conduct were eligible for these positions, but considerable wealth was also a requirement, since the holders of office had to finance public works schemes and gladiatorial shows.

IX, 7, 5-7

The painting on the front of this felters'
workshop is a lively specimen of popular
art. It shows the felters at work and
Verecundus himself displaying his
wares, which included cloth, clothes and
footwear. Altogether in Pompeii 207
craftsmen's workshops have been identi-
fied, trading in woollen, felt and leather
goods, baking, laundering, the various
kinds of smithery, pottery and so on.

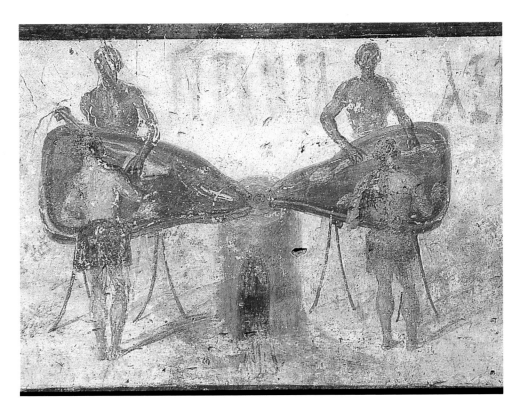

Paintings of Venus

Above the picture of the felters there is a Venus riding in a chariot pulled by elephants with a sceptre, rudder and the prow of a ship, the attributes of the goddess as protectress of seafarers. Close by is another painting showing a majestic Venus wearing a long tunic and a mantle. The cult of Venus, goddess of fecundity, was particularly important in Pompeii especially after Sulla made her the city's patron saint on founding the Roman colony, which bore the name Colonia Cornelia Veneria Pompeiana. This was the period in which the temple of Venus was erected, on the southwestern tip of the spur overlooking the sea (see p. 23).

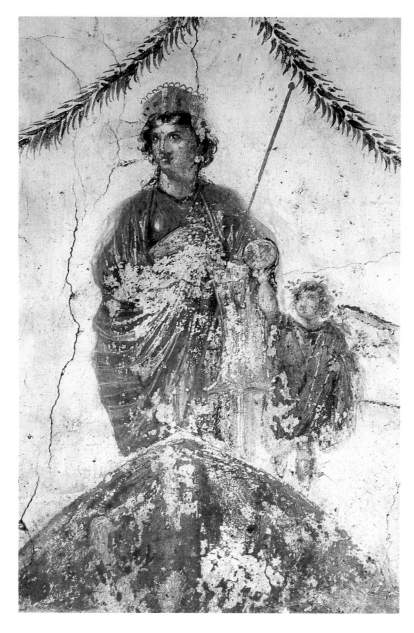

I, 6, 7

One of the four large fulleries (the establishments of the *fullones* or clothworkers) found in Pompeii, together with fourteen smaller concerns. The previous house was completely restructured to create the laundering facilities on the ground floor and living quarters upstairs. We do not know whether the Stephanus named in an electoral slogan on the shopfront was the owner or shopkeeper. Inside the entrance stood the press where the washed clothes and material were pressed.

Washing tanks

In the house as it had been, the roof of the atrium would have had an opening to allow rainwater to collect in the impluvium. During the restructuring, this pool was converted into a tank for either washing or rinsing the more delicate items. The roof was covered over, creating a terrace roof where items could be laid out to dry. The walls were rather perfunctorily decorated in the "fourth style" (see A9).

At the rear of the building, beyond the small peristyle, on the right is the kitchen, which must have provided meals for the employees, and on the left the series of tanks used for washing and rinsing. Washing was done in the small oval vats, where the fullers trampled the clothes in a detergent made of water and soda (soap was not yet known) or urine. Then they were rinsed in the three large tanks, placed one below the other and interconnecting.

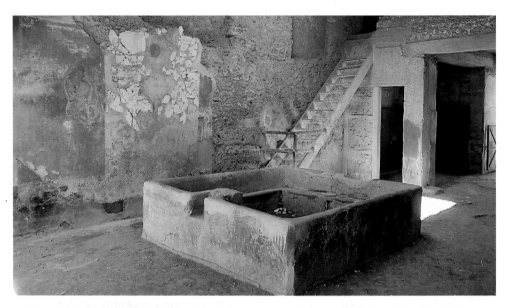

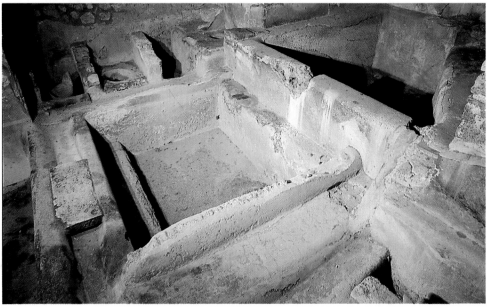

VII, 1, 8

This bathing establishment dates from the 2nd century BC, and was restored and enlarged in the first years of the Roman colony (80-70 BC). The bathing rooms, for men and women respectively, occupied the east wing of the palaestra, with a portico running round three sides as was the rule in all baths of this period. From the vestibule, off which was the *frigidarium* (a round room with a pool for a cold bath), one went into the spacious *apodyterium* (changing room), then the *tepidarium* (warm room) and finally the *caldarium* (hot room). The furnaces used to heat the water were situated between the *caldaria* of the male and female sections. The other large bathing establishments in Pompeii were the Forum Baths (A12) and the Central Baths, under construction in 79 AD.

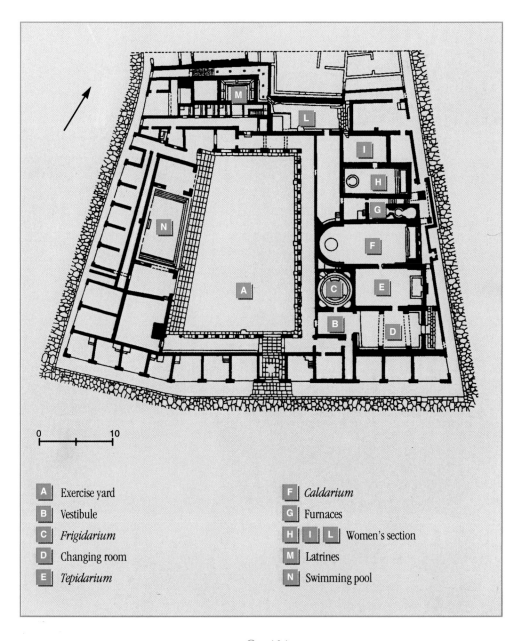

0 10

A Exercise yard
B Vestibule
C *Frigidarium*
D Changing room
E *Tepidarium*
F *Caldarium*
G Furnaces
H I L Women's section
M Latrines
N Swimming pool

Palaestra

As we learn from an inscription found inside the establishment, the great courtyard and portico were rebuilt by the duumvirs Caius Julius and Publius Aninius in the time of Sulla (see C3). This courtyard or *palaestra* for physical exercises and training was probably the nucleus of the original building on the site, going back to the 4th-3rd century BC and with a row of cubicles for bathing along its north side. A latrine was subsequently added, and an open air pool on the west side. Since only the most opulent houses had their own bath suites, the public baths must have been very popular. The admission charge was minimal and they were open from morning to night, although the customary time for bathing was apparently early afternoon, between midday and 4 p.m.

The southwestern wall of the *palaestra* was richly decorated in polychrome stucco during the second half of the 1st century AD. The compositional scheme of the "fourth style" features figures of athletes as well as mythological personages: Jupiter enthroned, with sceptre and eagle; a satyr offering Hercules a

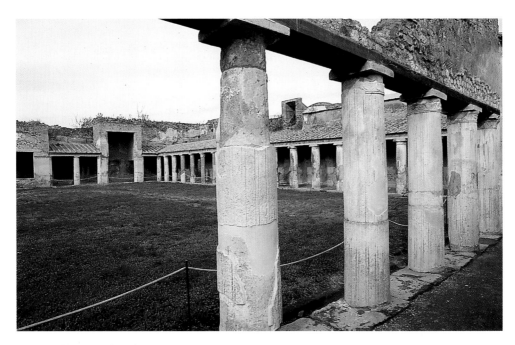

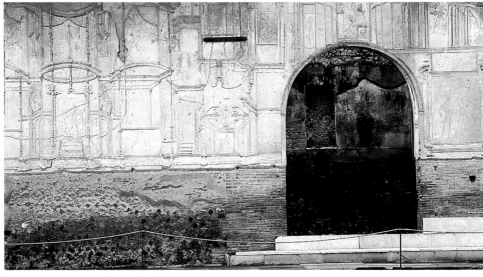

drink, and so on. The plasterwork deco-ration derives from the Greek world. In the Republican Age stucco was used, as in the "first style" of painting current in Greece, to imitate marble architec-tonic structures. During the 1st century BC it began to be used to model figures, and in the second half of the 1st centu-ry AD stucco reliefs, now also coloured, spread over the vaults of ceilings as well as the walls, reproducing the schemes of the "fourth style" of painting.

Vestibule

In the entrance we see a fine example of polychrome stucco work (although few traces of colour remain) which was applied to the vault in Flavian times, possibly during the restoration work following the earthquake of 62 AD. It comprises round medallions and poly-gons with convex sides linked by curv-ing tracery, with relief figures of nymphs, cupids, rosettes and so on. The compositional scheme is the same as that found in some mosaic floor designs of the same period.

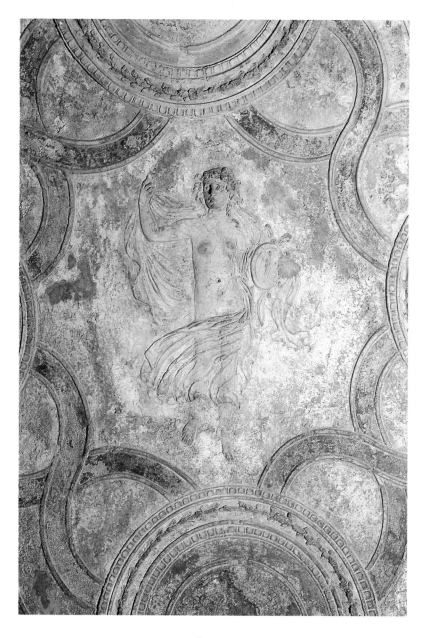

Frigidarium

The first, round bathing room (*frigidarium*) is almost completely taken up by the cold pool. The plasterwork on the walls, now almost entirely lost, showed garden scenes, while the domed ceiling represented a starry sky. This room was added in the time of Sulla and was originally intended as a sweating room (*laconicum*). The heat came from a brazier set in the middle of the room, and the temperature was controlled by raising or lowering a bronze disc placed across the opening in the ceiling.

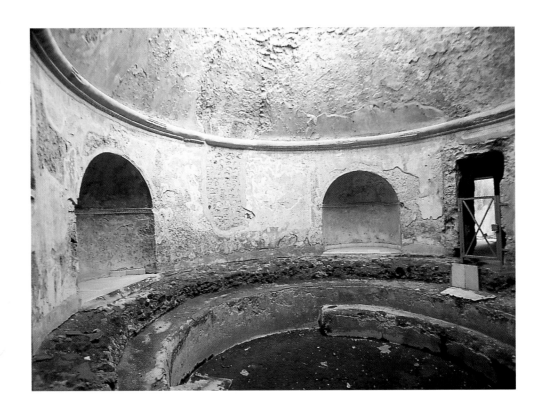

Apodyterium

The spacious changing room was provided with the usual recesses in the walls for depositing clothes and personal effects. Here too the decoration of the ceiling and lunettes is in stucco relief. Originally vaulted ceilings were decorated in imitation of wooden "box vaulting", but the stucco craftsmen gradually freed themselves from this tradition. Decorative schemes became more inventive and figures took on ever greater importance. Stucco was frequently used in bathing establishments on account of its resistance to humidity. In this room the plastercasts of two victims of the eruption are displayed (see B9).

Hot rooms

The *tepidarium* and adjacent *caldarium* were still being restored when the eruption struck. Here one can see clearly the heating system that came into use early in the 1st century BC. The mosaic floor was built up on brick stacks (*suspensurae*) and thus raised above floor level. The hot air produced in the adjacent furnaces passed under the floor and up the air ducts built into the walls so that the whole room was enveloped in hot air.

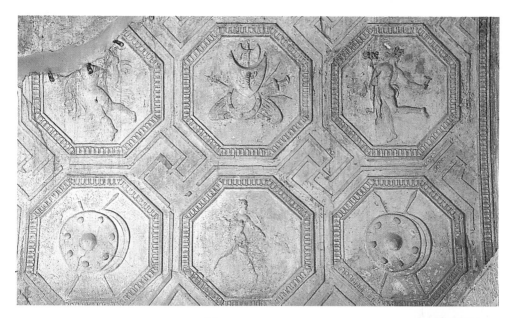

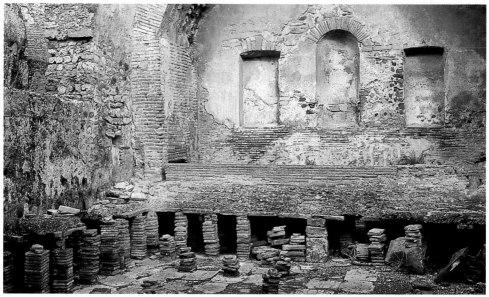

This road, the city's only north-south artery, divides the city in half and links the Porta Vesuvio (C11) with the Porta di Stabia, on the road to the ancient city of Stabiae. This accounts for the name of the road, which like all the other road names is simply a modern convention (see B1). It slopes steeply from north to south and probably occupies an old water course along which rainwater drained off the lava mass. When the aqueduct was constructed (see C10) numerous public fountains were set up, often at street corners. Crossroads were also the sites for the "elevation towers", pillars surmounted by a small tank from which water was distributed through pipes let into the pillar, making it possible to control the water pressure.

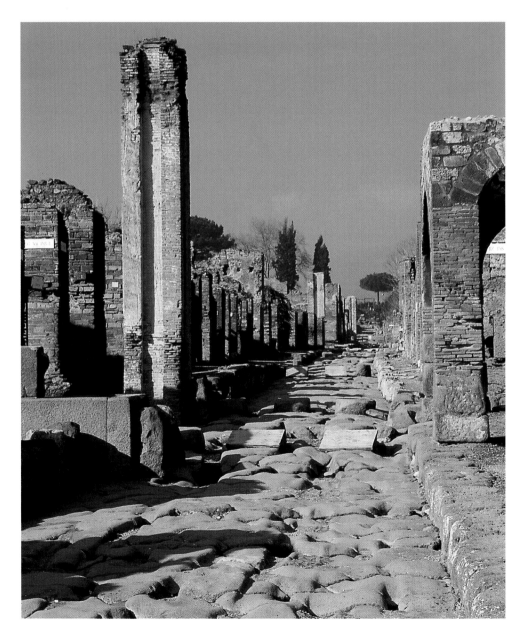

V, 4, A

From the electoral slogans found on the walls of this side street it appears that the householder was the aedile and duumvir M. Lucretius Frontone (see C3). It is another "atrium house", with the usual layout of entrance, atrium, tablinum.

To the left of the entrance is the room of the slave who acted as house porter; to the right the dining room for winter use, decorated in the "fourth style" with mythological scenes, and a bedroom in the "third style" with pictures of Theseus and Ariadne and Venus at her toilet.

Beyond the tablinum is a courtyard leading into the garden and portico opening onto other rooms including the summer dining room.

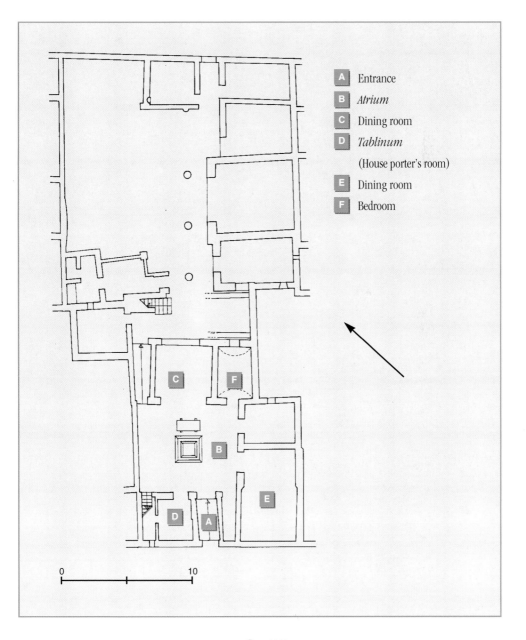

A Entrance

B *Atrium*

C Dining room

D *Tablinum*

 (House porter's room)

E Dining room

F Bedroom

0 10

Atrium

The pool of the impluvium is surrounded by a mosaic with plait motif while the rest of the floor is in *lavapesta* adorned with flakes of marble.

The walls are plastered and decorated in a sober version of the "third style". Here one can clearly see the character- istic tendency to remain two-dimensional, without seeking the vistas offered by perspective, and the close attention to detail, which is often very finely wrought.

Next to the impluvium, as often, stands a marble table or sideboard (*cartibulum*) for the dinner plate.

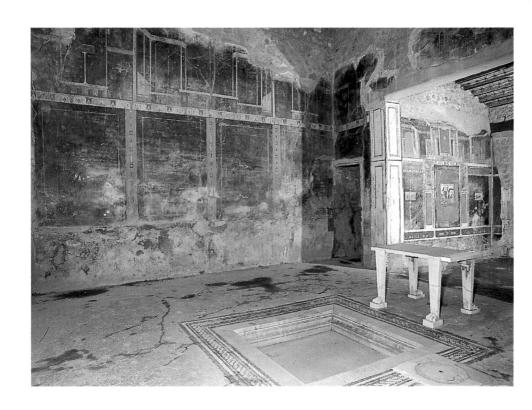

Tablinum

The walls of the tablinum constitute what is probably the best example of late "third style" decoration, rich in exquisitely traced detail and architectonic views in which perspective is used, paving the way for the subsequent "fourth style". The centre of each wall is dominated by scenes (rather smaller than in the early and middle "third style") from mythology: the Triumph of Bacchus and Ariadne on the south wall and Mars and Venus on the north. In the side panels there are small pictures showing seaside villas based on actual buildings, a common motif in this and the subsequent "style". The bottom section of the wall is decorated with the characteristic motif of the enclosed garden, while the upper part is already adorned with the architectural fantasies and imaginative perspective that were to become the hallmark of the "fourth style" (see A9, p. 43).

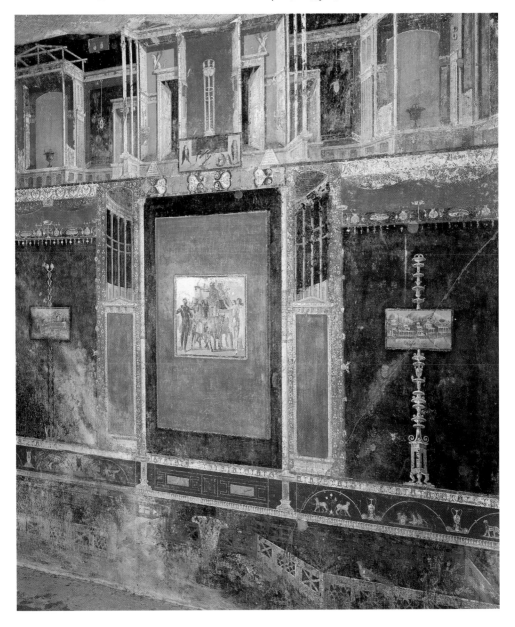

Triclinium

The picture in the winter dining room depicts the Killing of Neoptelomus by Orestes at the sanctuary of Apollo in Delphi, an episode from Euripides's tragedy *Andromaca*. Neoptelomus had married Hermione, the cousin of Orestes, although the two were already betrothed. Orestes kills his rival and regains his beloved, seen in the foreground. In the background is a representation of the temple of Apollo.

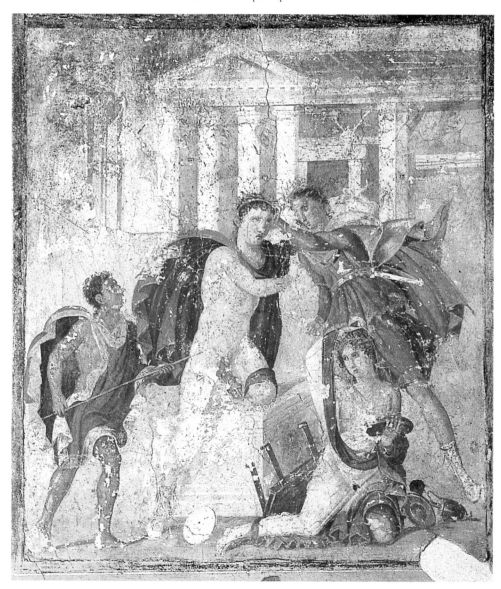

Cubiculum

The roundels on either side of the doorway of this room were decorated with the faces of a boy and girl, so that it may have been their bedroom (*cubiculum*). The boy is portrayed with the attributes of Mercury (the winged helmet and wand).

On the other walls are scenes from the famous myths of Pero suckling her father Mykon, thus saving his life while he was imprisoned, and Narcissus. The youth was punished by the goddess Nemesis for repulsing the love of the nymph Echo; he fell in love with his own image, reflected in a pool, and drowned in attempting to embrace the image. The flower that sprung up in that spot took his name.

Garden

On the walls of the garden is a broad landscape in which both wild and domestic animals are seen roaming free, pursuing one another and fighting. This kind of scene came into vogue with the "fourth style" (in the second half of the 1st century AD), adorning garden walls more often than not in the smaller houses, with the aim of creating the illusion of spaciousness by analogy with the hunting grounds of the large patrician villas. This garden and portico were created on a site previously occupied by a neighbouring house.

VI, 16, 7

This takes its name from the cupids engraved on gold plaques (now in the Naples Museum) which decorated one of the rooms opening onto the peristyle, possibly the bedroom of the master and mistress of the house. Graffiti suggest that the house belonged to Cn. Poppaeus Habitus, a relative of Poppea the wife of Nero. On either side of the entrance are bedrooms with traces of decoration in the "first style". The entrance and sober atrium leading through to the tablinum show the original layout of the house, which was repeatedly enlarged and modified between the end of the 3rd century BC and the 1st century AD. As we see it now its centrepiece is the large peristyle with the garden, giving access to the reception rooms. The servants' quarters, with the kitchen and latrine, are tucked away in the northwestern corner of the site, inside the back entrance.

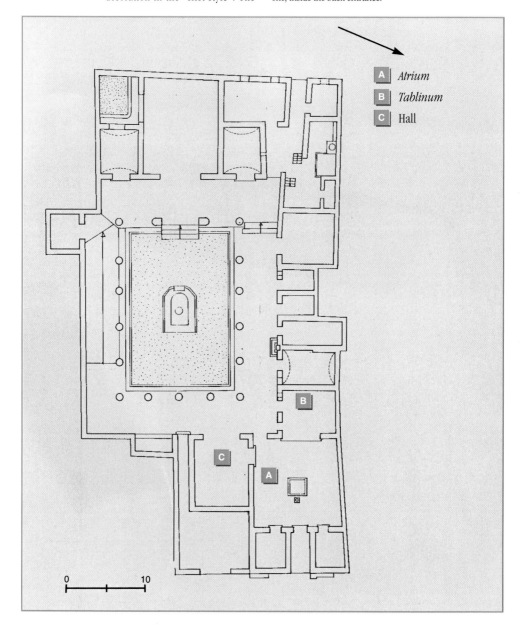

A Atrium
B Tablinum
C Hall

0 10

Hall

The main reception room, on the east side of the peristyle, is spacious and decorated in the "third style" with fine scenes from mythology in the central panels, that often included architectonic and landscape elements, a feature that was to disappear in the "fourth style". On the back wall there is Jason, wearing only one sandal, meeting king Pelias. The king fears an oracle that foresaw his death at the hand of a man wearing one sandal, and he tries to get rid of Jason by sending him on the arduous quest for the golden fleece. The hero, at the head of the Argonauts, succeeds in bringing back the fleece and becomes the unwitting cause of the king's death.

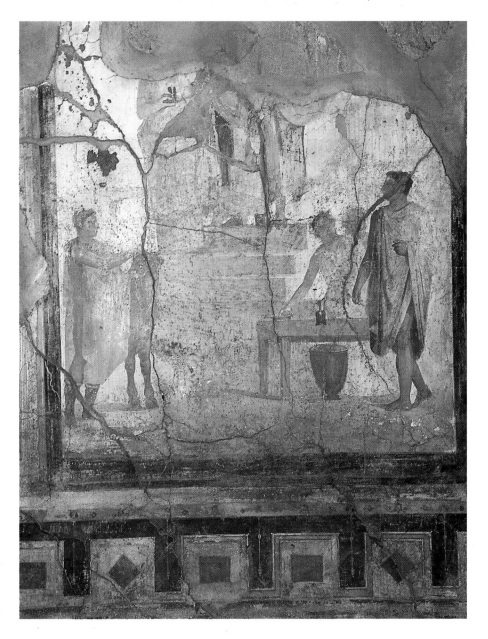

Hall

The floor, in black and white mosaic, is dominated by the large rose design in the centre. In the "second style" a reception room generally featured a polychrome mosaic picture in the centre of the floor, whereas from Augustan times onwards the fashion was for black and white mosaics with geometrical designs (see A30, p. 86). Mosaics were made by first laying down a compound of mortar and crushed stones, then a layer of mortar and crushed brick, covering this with a layer of white plaster. The guidelines for the design were drawn on this surface, and the tesserae were then applied one by one. Mosaic floors were expensive and are found only in affluent houses, particularly in the reception rooms and the baths.

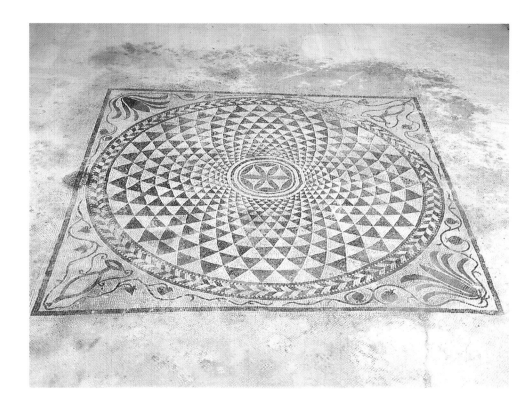

Garden

The peristyle and garden were adorned with a large number of small statues and marble reliefs (no longer *in situ*), theatrical masks and round *oscillae* (carved discs suspended in the arches of the peristyle), short sculpted columns and Dionysiac herms or animal heads. These ornaments express the fashion that came in during the 1st century AD for imitating the large country villas (see B2, A18). However, when the *nouveaux riches* of Pompeii wanted to recreate the collections of sculpture that adorned the patrician parks they favoured the more popular motifs evoking nature (animals) and the Dionysiac cult (herms of the god, satyrs, theatrical masks). In addition, small statues deriving from Greek models were used as fountains.

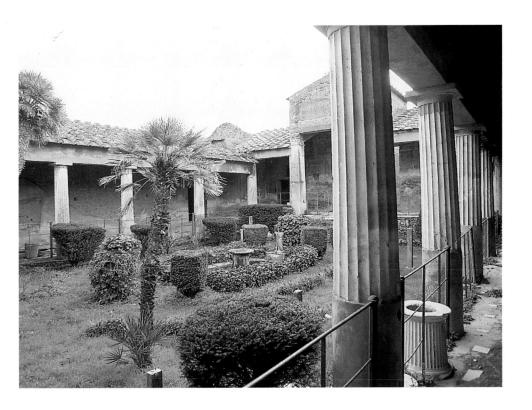

Lararium of Isis

The peristyle contains two lararia, one in masonry for the veneration of the traditional divinities (see A30), and another one painted on the wall showing Egyptian gods. Thus the householder was evidently susceptible to the Eastern religions, showing a syncretism which was common among the Romans. We see the jackal-headed Anubis, the god of the dead assimilated to the Roman god Mercury, "conductor of souls"; Harpocrates, who corresponded to the child god Horus, son of Isis and Osiris; Isis and Serapis, divinities from the Greek and Egyptian tradition which were assimilated to Dionysus and Aesclepius, the latter being invoked as a healer and saviour (see A29, B2). Alongside the portraits there are various objects associated with the cult of Isis including the sistrum, guarded by the sacred cobra (*uraeus*), and along the bottom the customary agathodemons or beneficent snakes (see C1).

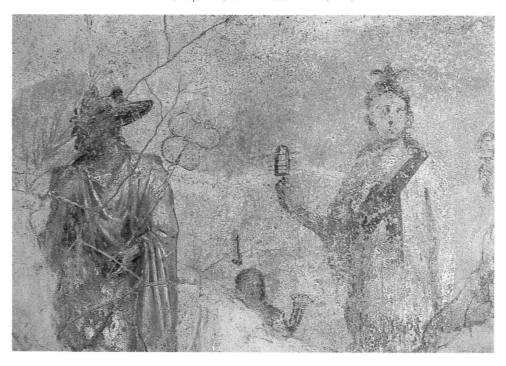

The aqueduct starting from the springs of Acquaro near Serino was built under Augustus to supply the naval base in Misenum, and subsequently another branch was added to serve Nola and Pompeii. The *castellum* was built on top of the city walls next to the Porta Vesuvio (C11), at the highest point in the city to facilitate the water's distribution. The wall on the south side in *opus lateritium* seems to be part of restoration work following the earthquake of 62 AD and subsequent tremors. Before the arrival of the aqueduct, citizens had to rely on rainwater collected in the domestic impluvium, and on the public wells which reached down to the water table.

Inside there is a cistern with three outlets serving different parts of the city. Distribution was regulated by a system of metal shutters that could be raised or lowered, and the water was delivered through lead piping. It went not only to public fountains and establishments such as the baths, but also to the private houses of the rich. In 79 AD much of the water system was being renovated. The side walls are in *opus reticolatum*, made of pyramid-shaped stones embedded in an inner core of mortar with their square bases presenting a compact external surface.

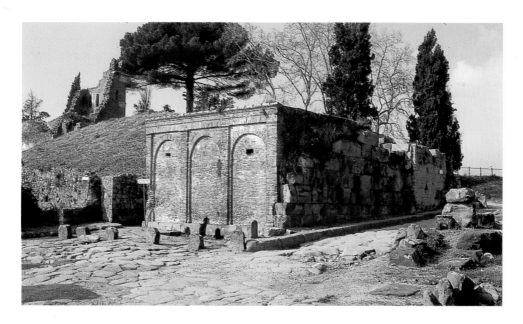

City walls

Little remains of the gate that stood at the northern end of Via Stabiana guarding the road that led to Vesuvius (hence the name), which suffered badly from the earthquake in 62 AD. What can be seen, outside the gate to the right, is one of the few stretches of wall dating back to the 5th century BC. Other traces of this wall have been found at Porta Ercolano below the Tower of Mercury, at Porta di Stabia and between the III Tower and the amphitheatre. This wall, like contemporary Greek fortifications, comprised a double row of stonework in large limestone blocks built over a central earthwork core (see also B11).

Towards the end of the 3rd century BC, probably prompted by Hannibal's advance into Campania during the Second Punic War, the previous structure in limestone blocks (see p. 18) was made higher and partially rebuilt in tufa. Round the top of the walls ran a passageway for guard duty reached by wide flights of steps up the earthwork (see C 13). Later, during the Social War which saw the Italic cities in conflict with Rome at the turn of the 1st century BC, towers were added, constructed in the latest technique of *opus incertum* (unshaped stones embedded in an inner core of mortar and crushed stone presenting a flat external surface)

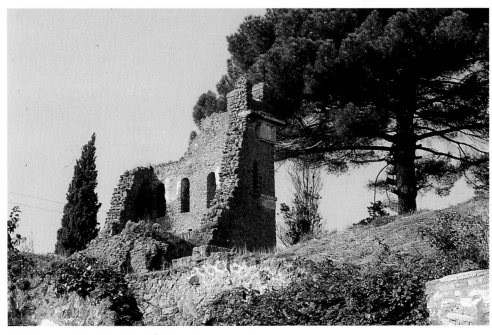

Tombs of Tertulla and Septumia

Outside each of the city gates (with the apparent exception of Porta Marina) one finds a necropolis lining the road leading away from the city (see C14). The tombs are of several types. One frequently found has a semicircular base with a column rising out of it ("*a schola*") and general-ly belonged to a woman of importance, perhaps a priestess or the wife of a magis-trate. The tomb with a rectangular base bearing a column (on which must have stood a marble vase) belonged, as we learn from the epigraph, to Septumia, who received the site and money neces-sary for burial from the city council.

Tomb of Vestorius Priscus

This comprises an enclosure round a plinth bearing an altar (see C14). The inside walls of the enclosure and the faces of the plinth are painted with hunting scenes, a gladiatorial combat and episodes from the life of the incumbent. The altar is decorated with plasterwork in relief showing maenads and a satyr. The epigraph records the aedile Caius Vestorius Priscus, who died at the age of twenty two (see C3). This tomb too lies within the perimeter belt, and the decurions had authorised its erection (C 14).

The fresco on the northeastern wall of the enclosure shows a table bearing a rich display of silverplate, proclaiming the social standing of the incumbent. We know that the young man served as aedile in the year 75-76 AD, and thus this monument was among the last to have been built when the eruption struck in 79 AD.

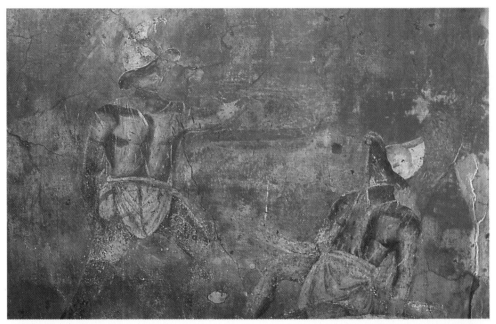

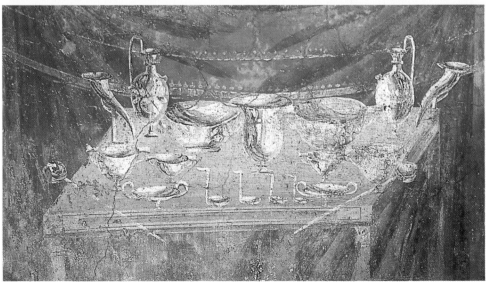

This gate is not fortified and must have been built after Sulla's conquest of the city, when the defences were no longer necessary. It is constructed in *opus vittatum mixtum*, a core of mortar and crushed stone faced with small blocks of tufa or limestone alternating with bricks. It should be specified that all the types of walls we have described were plastered over. On the right outside the gate there are remains of a flight of stairs leading to the passageway round the walls.

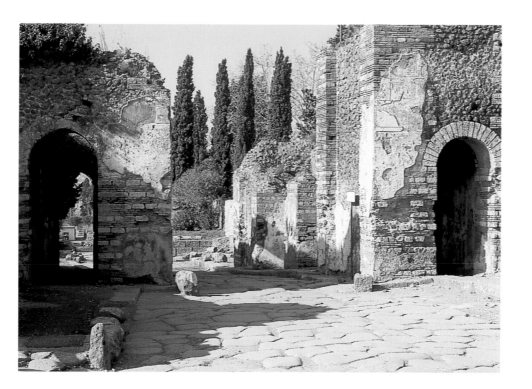

This is the most famous of the necropolises of Pompeii and was excavated repeatedly in the years between 1763 and 1838 (the first excavations of the city itself took place in 1748). It lies alongside the road leading to Herculaneum and Naples.

Legally there had to be a belt of 30 metres left free of buildings round the city perimeter, but it was not uncommon for important personages to be granted the right to erect their tombs within this limit. Funerary monuments on this site date from the middle of the 1st century BC to the second half of the 1st century AD.

In this period the bodies were usually cremated and the vase containing the ashes was either incorporated in the structure of the tomb or buried at its foot, often marked by a schematic human torso (*columella*).

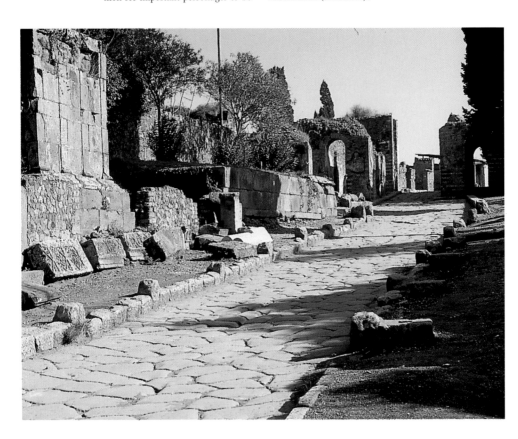

Tombs of Mamia and the Istacidii

The tomb with the semicircular base (*schola*: see C12) is that of the priestess Mamia, as we learn from the epigraph on the backrest. The tomb behind it belonged to the Istacidii, one of the most important Pompeian families in Augustan times. It comprises a large funerary chamber surmounted by a circular aedicule, with statues of the family's most prominent members set up between the columns.

Tombs of Calventius and Naevoleia Tyche

Both tombs are of the "altar" type and date from the reign of Nero (54-68 AD). The altars still have their marble facing with reliefs recording the exploits of the dead men. The one dedicated to the Imperial priest (*augustale*) Caius Calventius Quietus shows, among other things, the double seat (*bisellium*), set up in the front row at theatrical performances. The other altar, with the joint dedication to Naevoleia Tyche and the priest Caius Munatius Faustus, shows a small portrait of Naevoleia, the *bisellium* and also a cargo ship alluding to the latter's commercial activities.

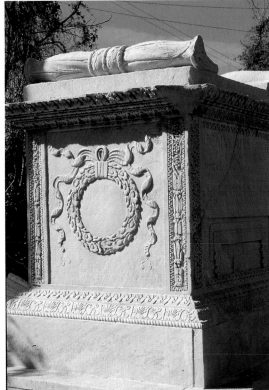

This country villa probably belonged to the Istacidii, to judge from an inscribed signet ring found here. Its construction is generally held to date from the 2nd century BC, with important renovation being carried out in about 60 BC and again the 1st century AD. It is built on ground that slopes down towards the sea, which at that time would have been quite close.

The incline was filled in to make a terrace supported by a cryptoporticus. More than one hundred villas are known dotted over the surrounding countryside, existing above all as working farms but almost invariably with residential quarters which were often very sumptuous. They testify to the fashion for having a country holiday retreat which caught on

among the upper classes from the middle of the 2nd century BC onwards. Furthermore they were an attempt to create, by means of verdant vistas, porticos offering fine views and sophisticated decorative schemes, premises imbued with that Hellenistic culture which the Romans had recently come to know at first hand.

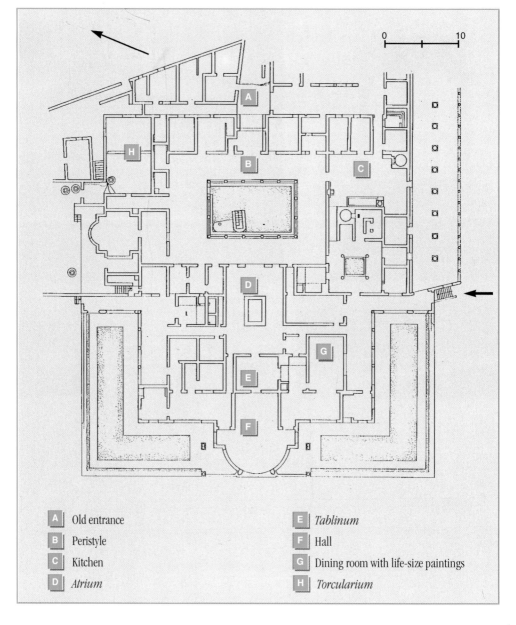

A Old entrance	E *Tablinum*
B Peristyle	F Hall
C Kitchen	G Dining room with life-size paintings
D *Atrium*	H *Torcularium*

Peristyle

Standing on the road which led from Pompeii to Herculaneum, it comprises the residential quarters (facing west and overlooking the sea) and servants' quarters (facing east) next to the area for wine production, which occupied the north side. The entrance on the east side opened directly onto the spacious peristyle that served the various parts of the villa, including the large kitchen and the baths on the south side. Here too the residential quarters are laid out according to the sequence of atrium, tablinum and living room with a semicircular exedra. These rooms are mainly decorated with splendid frescoes in the "second style" (see p. 157), dating from the renovation carried out in about 60 BC.

Torcularium

In the torcularium stood two presses (one of which has been reconstructed) for pressing out the grapes. The massive wooden trunk sculpted with a ram's head was lowered by means of a pulley onto the grape pulp which had already been trampled on. The juice poured down a channel into the cellar where it was conserved in huge terracotta jars (*dolia*) set into the floor. Viticulture and wine making were fundamental activities in the economy of Pompeii. The plain of Sarno and slopes of Vesuvius were covered with vineyards, yielding abundant wine of different qualities, much of which was exported.

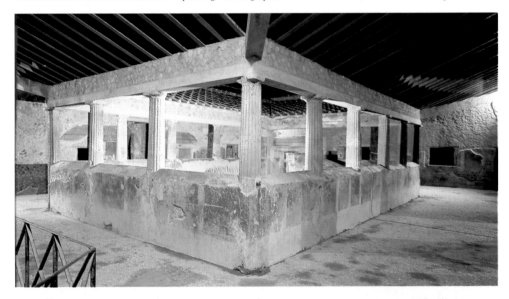

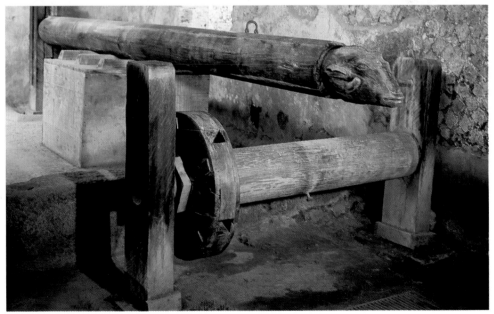

Triclinium

The fresco running round all four walls of the dining room is a *megalographia,* with life size figures, in the "second style" and based on Alexandrian models. Its interpretation has provoked much debate, and the name given to the villa reflects the hypothesis that it shows the initiation rite into the Dionysiac mysteries. It certainly seems to illustrate a female initiation connected with the cult of Dionysus.

The cycle culminates on the rear wall with Dionysus in a state of inebriation slumped in the lap of a female figure enthroned, possibly Ariadne. The room has one of the rare examples of a floor tiled in marble.

Cubiculum

The "second style" of wall decoration prevailed from the beginning of the 1st century BC to the years 30-20 BC. The plasterwork was painted with architectural elements, at first simply colonnades but becoming progressively more elaborate, giving the effect of three dimensions and perspective, as if the wall opened out onto a portico with gardens and buildings created with *trompe l'oeil* effects. The architecture depicted is basically true to life, whereas in the subsequent "styles" it became stylised and fantastic (see C1 p. 123, C8 p. 139, A9 p. 43). This decoration was used in the reception rooms of houses and villas to give the illusion of more space and increase the magnificence of the hospitality.

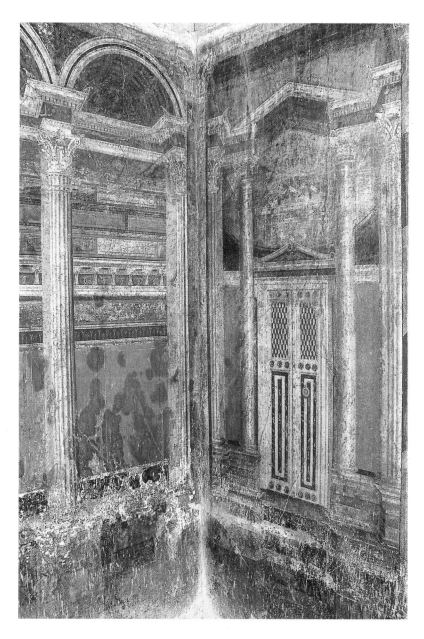

Tablinum

The walls of this tablinum provide one of the best examples of the "third style" of wall decoration with a black background. The walls are divided into three parts by motifs executed in exquisite detail, particularly on the predella with Egyptianizing scenes. These were faithfully copied from Egyptian sources without any real understanding of their significance, and reflect the close contacts between Rome and Egypt following Octavian's conquest in 31 BC. Their linearity as colourful, strictly two dimensional designs was perfectly suited to the decorative schemes of the "third style".

Thematic Index

Index of places and buildings

Printed may 2000

Typeset: Grafica Elettronica
Photolithos and print: SAMA
Binding: Legatoria S. Tonti, Mugnano, Napoli